Cave-in-Rock
PIRATES
— & —
OUTLAWS

TODD CARR

THE
History
PRESS

Published by The History Press
Charleston, SC
www.historypress.com

First published 2019

Manufactured in the United States

ISBN 9781467140485

Library of Congress Control Number: 2019932640

This book is dedicated to the young and young at heart who have stood in the cool recesses of the Cave and listened for river pirates in dark corners.

Contents

ACKNOWLEDGEMENTS

For the love of money is the root of all evil: which while some coveted after, they have erred from the faith, and pierced themselves through with many sorrows.
—I Timothy 6:10

I'd like to thank photographer Charles Hammond for access to the Trigg Collection of photographs and the picture of Logan Belt. Thanks also go to Jeff Robinson. Whenever I have need of old photographs of Hardin County, he is the go-to person. The resources of the Hardin County Historical and Genealogical Society and its members also added much to the book.

The work of historians as reported in *Springhouse* magazine became a wealth of factual information. I'd especially like to acknowledge the research and reporting of Gary DeNeal, Ronald Nelson and Jon Musgrave, among others. Thanks also go to the historical dynamic duo of Mary McCorvie and Dr. Mark Wagner for ferreting out the "fact" from the "lore."

Thanks also to my family, Alene, Rachel, Allison and Leah, for letting me do my writing thing. To my friends, thank you for the distractions. They recharge the brain.

Some teachers instruct the curriculum and that's that. My third-grade teacher instilled in me a lifelong love of reading. For that gift I'll be forever grateful. When she also happens to be a Cave-in-Rock folklorist who's entertained countless people on riverboat excursions and tour buses with tales of counterfeiters, river pirates and horse thieves, well,

there's a bit of Patsy Ledbetter on practically every page of this book. Thank you, Mrs. Ledbetter!

Finally, thank you to my acquisitions editor, Ben Gibson, with The History Press. It was his desire that this book become reality. I was just the facilitator.

INTRODUCTION

For about three or four miles before you come to this place, you are presented with a scene truly romantic. On the Indian side of the river, you see large ponderous rocks piled one upon another, of different colours, shape, and sizes. Some appear to have gone through the hands of a skillful artist; some represent the ruins of ancient edifices; others thrown promiscuously in and out of the river, as if nature intended to show us with what ease she could handle those mountains of solid rock. You see again purling streams winding their course down their rugged front; while in a moon-light night, added to the murmuring noise they occasion, is truly beautiful, though it rather disposes the mind to solemnity: while others, project so far that they seem almost disposed to leave their doubtful situations. After a small relief from this scene, you come to a second, which is something similar to the first; and here, with strict scrutiny, discover the cave. Before its mouth stands a delightful grove of cypress tress arranged immediately on the bank of the river. They have a fine appearance, and add much to the cheerfulness of the place. The mouth of the cave is but a few feet above the ordinary level of the river, and is formed by a semicircular arch of about eighty feet at its base, and twenty-five feet in height, the top projecting considerably over, forming a regular concave. From the entrance to the extremity, which is about one hundred and eighty feet, it has a regular and gradual ascent. On either side is a solid bench of rock; the arch coming to a point about the middle of the cave, where you discover an opening sufficiently large to receive the body of a man, through which comes a small stream of very clear and well-tasted water, which is made use of by those who visit this place.

From this hole a second cave is discovered, whose dimensions, form, etc., are not known. The rock is of lime-stone. The sides of the cave are covered with inscriptions, names of persons, dates, etc.
—botanist Thaddeus Harris (1795–1856) on an 1803 trip down the Ohio River published in The Journal of a Tour into the Territory Northwest of the Alleghany Mountains, *printed in 1805*

The Cave is the natural landmark and namesake of Cave-in-Rock, a small town on the banks of the Ohio River in Hardin County, Illinois. It was a place the Native Americans called "the habitation of the Great Spirit." It's thought the Cave had a spiritual meaning to the prehistoric peoples who lived here. Several decades ago, Indian stone graves were found near the Cave with five to ten skeletons inside each.

The first Europeans to visit the Cave were the French, who called the region New France. They began settling this area of the Illinois Country in the sixteenth century. The French ceded the land to Great Britain and Spain in 1763 at the conclusion of the French and Indian War. Hernando de Soto of Spain might have been in the area in 1540, but most historians don't believe his expedition came this far north.

During the American Revolution, Colonel George Rogers Clark passed the Cave on his expedition to claim the Illinois Territory from Great Britain when he defeated the British forces at Kaskaskia (Illinois) and Vincennes (Indiana). At the conclusion of the American Revolution, the region north of the Ohio River was reorganized into the Northwest Territory. Much of the land outside old French and British outposts was in control of Native American tribes.

The American Revolution's devastating effect on social and economic conditions in the original colonies caused a migration to the Upland South region of Tennessee and Kentucky and eventually the Northwest Territory north of the Ohio River. Trails into the frontier in many cases were old buffalo and Indian traces. The Wilderness Road blazed by Daniel Boone led to Kentucky and Tennessee. The Cumberland Road followed a more northerly route through Virginia (West Virginia) and Pennsylvania into Ohio. The Cumberland Road eventually became the National Road, the first major road built by the United States government.

Zane's Trace was pioneered by Colonel Ebenezer Zane through Ohio, and Avery's Trace, laid out by Peter Avery, connected Knoxville, Tennessee, with the Nashville area. The Cumberland, Tennessee, Ohio and Mississippi Rivers, however, were the earliest forms of an interstate transportation

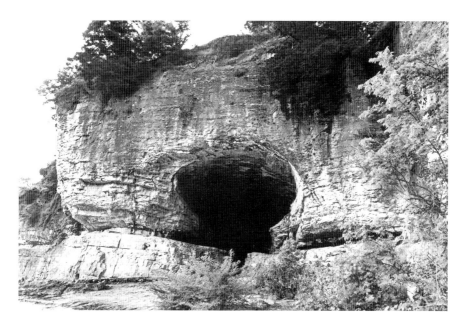

The Cave at Cave-in-Rock State Park as it looks today. *Author's collection.*

Many people have floated into the Cave by boat during Ohio River floods and left names on the ceiling of the cavern. *Author's collection.*

system and led to the rapid migration and development of what's now known as the Midwest.

Until the Coinage Act of 1857, Spanish money was considered legal tender in the United States and was in widespread use along with paper currency drawn on various banks. Very little counterfeiting was done prior to the Revolution. British forces then flooded the colonies with fake money as a war tactic. By the end of the war, American currency had so little value it didn't pay to counterfeit it. As the economy and commerce rebounded, the counterfeiter began to apply his trade.

Honest and hardworking pioneers moved with their families into what was then the western frontier. Desperate criminals fleeing from justice, escaped felons or those who sought the camouflage of the deep forests of the untamed interior came also. Often, settlers lived on the fringes of law and order. The horse thief, counterfeiter, highway robber and rogues of all sorts were living side by side with industrious Americans carving new states out of the land.

The Commonwealth of Kentucky gained statehood in 1792. Four years later in 1796, Tennessee became a state. Whenever a region became strong enough to enforce the laws of the United States, crime was no longer tolerated and outlaws were arrested and prosecuted. Often there was a continual struggle with the criminals and the legal system, so much so that citizens were sometimes called upon to form a local militia, called a Regulating Company or just "Regulators," to forcibly remove the ne'er-do-wells. In the frontier, Lynch's Law was in effect: a community of people who agree punishment should be inflicted without a legal trial. The punishment of choice was hanging by the neck until the perpetrator was dead, dead, dead.

The land the pioneers were settling was full of fertile soil. Settlers started producing surpluses of goods produced on their farms. Stone-ground flour, corn, livestock, hemp, flax, tobacco, cured meats, furs, leather and whiskey were all grown and manufactured in the resource-rich river valleys. About 1787, flatboats started to be constructed to transport these excess goods to markets in Natchez and New Orleans.

A flatboat was essentially a flat-bottomed raft with a cabin and corral built on top of it. They were easily handled by novices, as the river current provided the primary means of propulsion. The flat bottom meant the boat could travel in shallow water. When Native Americans were still a menace, sidewalls were made around the edges so the flatboats could be defended. From March to late summer, pioneers sent their surplus downriver to market,

where it was converted to cash. A flatboat was a one-way trip. Pioneers made their way back home by the Natchez Trace, an old Native American trail connecting Natchez, Mississippi, and Nashville, Tennessee.

Natchez was established by the French in 1716. After the French and Indian War, it was ceded to Spain, but colonists fought bitterly with the Spanish and the land was eventually traded to Great Britain. Even after the American Revolution, Natchez was fought over with Spain until 1795. The city became an important trade port on the Mississippi River and at one time served as the capital of the Mississippi Territory.

Why did Cave-in-Rock become the headquarters of criminals? Two factors came together at the right time. Few settlers were living in the lands north of the Ohio River and west of the Wabash River in what is today Illinois. When the Northwest Territory was created in 1787 there were only three major American settlements in the territory. The future states of Kentucky, Tennessee and Ohio were rapidly filling with settlers, and they brought law and order and, when necessary, Regulating Companies. Criminals were pushed into the relatively empty Illinois Territory. The other factor was the increasing amount of trade traveling the rivers with relatively little protection.

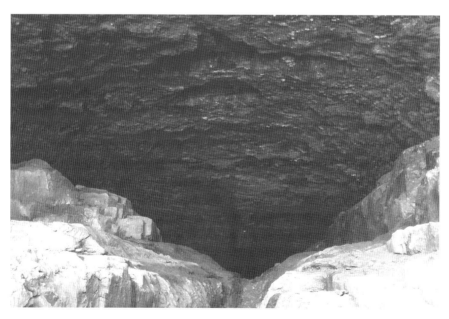

The vaulted ceiling is a uniform shape and width the entire length of the Cave. *Author's collection.*

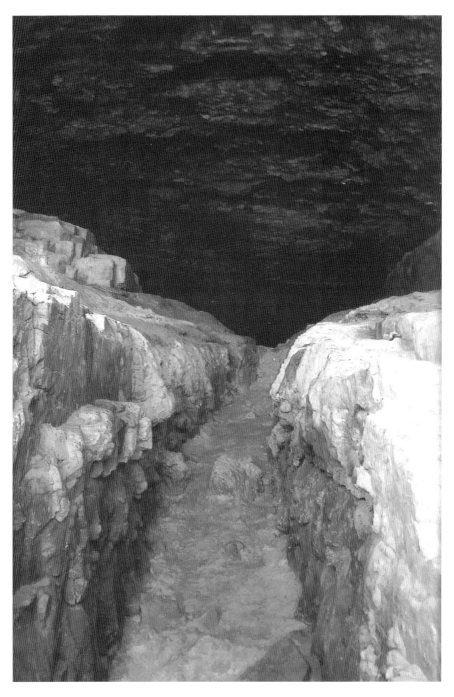

No one knows who or when this entrance path was carved through the shelf of rock that serves as the base of the Cave. *Author's collection.*

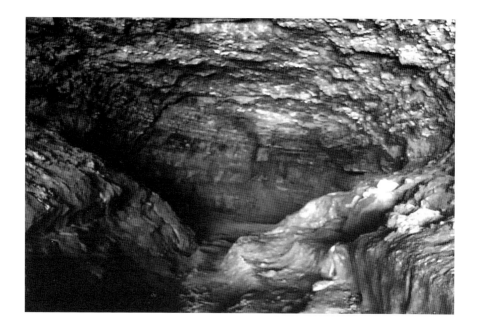

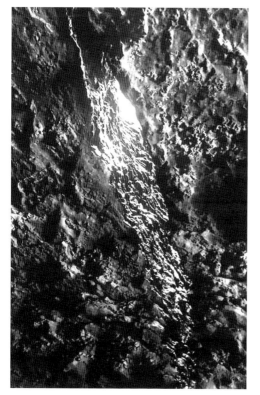

Above: The back recesses of the Cave are lit by a single shaft of light entering through the "chimney" to the surface. *Author's collection*.

Left: The "chimney" in the back of the Cave leads to the bluff above and provided a perfect escape for the river pirates' smoke. It also allows light to enter to explore the cavern's interior. *Author's collection*.

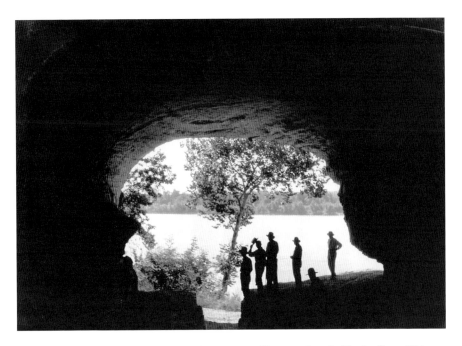

One of the more popular photographs is to stage a silhouette from inside the Cave. This photo was taken on the 1931 Trigg Ozark Tour. *Trigg Collection, courtesy of Charles Hammond.*

The factors that made the Cave so attractive to outlaws also led to its demise as a hideout. The Indiana Territory was created in 1800 when Ohio was taken from the Northwest Territory and granted statehood. William Henry Harrison was appointed governor of the new territory and granted powers to negotiate with the Native American tribes. All lands east of the Mississippi River in Illinois were eventually bought and secured for new settlement. The Kaskaskia tribe sold the land where the Cave is to the United States in 1803.

As had happened in Tennessee and Kentucky, the criminals in the Indiana Territory found they were too exposed and went farther west or were captured and brought to justice by the growing population. A flood of new commerce began when the Louisiana Purchase occurred in 1803 and brought boat- and wagonloads of new pioneers. Settlement and the growing populations brought statehood. The Illinois Territory was formed in 1809 when Indiana achieved statehood. Illinois became a state nine years later in 1818.

What follows is folklore: the stories, beliefs and customs of a small community on the banks of the Ohio River. In many cases, there are enough landmarks and place names left on these lands to make these legends seem historical fact. Unfortunately, the stories fall somewhere between fact and fiction. But don't let the truth keep you from enjoying a good story. Throughout these pages, you're invited to reenter a time when outlaws walked the streets and mischief lurked around every corner.

PHILIP ALSTON

Philip Alston was born in South Carolina about 1741. He was the son of Solomon and Ann Nancy (Hinton) Alston. His family later made their way to Raleigh, North Carolina. Although by all accounts he was born a gentleman and received an education, Philip Alston, along with his brother John, started a counterfeiting enterprise while living in Raleigh. About 1771, the citizens of the city became infuriated with the fake bills infiltrating their city and began looking for the counterfeiters in earnest. Alston was a member of the Regulator War against Royal Governor William Tryon. This uprising is considered one of the precursors to the American Revolution. With the Regulators defeated and the rising public sentiment against the counterfeiting, Alston fled to Natchez, arriving there in 1772.

By 1776, Alston had become one of the most prosperous citizens of Natchez. His legal business ventures included land speculating and farming. Alston was also a signer of the Cumberland Compact in 1780 at Fort Nashborough (now Nashville). This document was an early attempt at governing articles for what would become the state of Tennessee. Evidently, he split his time living on both ends of the Natchez Trace. In 1781, he was a participant in an uprising against the Spanish government at Fort Panmure. Natchez was in the West Florida Territory that changed hands several times between the British and French and American governments between the town's founding in 1716 through the French and Indian War and the American Revolution. The Natchez settlers captured Fort Panmure from the Spanish and held it until 1788, when Spanish soldiers retook the fort.

Alston returned to counterfeiting gold and silver coins of both the American colonies and Spain. He also circulated counterfeit American bank bills. He soon set his eyes on a golden prize. In the Natchez Catholic Church, there was a crucifix of Jesus Christ made of gold. Although he had been raised Presbyterian in the Carolinas, Alston joined the Catholic Church in order to steal the figure. To gain access to the sanctuary, Alston asked for a key so he could worship and do penance. The sexton granted his request. With private access to the sanctuary, Alston was able to remove the crucifix from the church.

Alston melted down the statue and used it to make gold coins. When the Catholic Church discovered the theft, Alston's property was confiscated, and he fled Natchez to save his life. He was also excommunicated. The historical record shows that Alston then lived for a time at Mansker's Station, Tennessee (now Goodlettsville).

Alston then appears in Logan County, Kentucky, in 1782 or 1783, settling on the Red River in what became known as Alston's Station. Alston had a claim to all the best lands of the region because any land he needed around Red River, he counterfeited a deed for it. Occasionally, Alston would be called on the fake deeds. He would respond with a joke and a smile and let the matter drop. During the summer of 1784, Alston began farming, and that fall he began manufacturing salt with John Stuart at nearby Moate's Lick. He also managed the Cedar House, a roadside tavern near Russellville, Kentucky.

Alston's daughter Frances married James D. Dromgoole in 1782. Alston entered into business with his son-in-law opening the first trading post in the area. The two men traded salt obtained from the Moate's Lick operation for animal hides from settlers and trappers. The tanned hides were then taken to Natchez or the eastern states to purchase goods for the store. Dromgoole left Alston's Station in 1788 to start a similar operation, Dromgoole's Station (now Adairville, Kentucky).

About 1786, Alston started counterfeiting again, spreading fake money throughout western Kentucky. One day, his son Peter was passing a counterfeit gold piece. The receiver realized the coin was fake and began an argument over it. Alston intervened and asked to see the coin to determine whether it was genuine or not. He held the coin to his mouth and blew on it, which he led everyone to believe would determine if it was brass or copper. This wasn't the first time Alston had done this when caught passing counterfeit coins. With a practiced sleight of hand, he brought a good coin to his mouth and either pocketed or swallowed the fake one. He

then chastised the crowd for doubting his son and passed the genuine coin around for all to see.

Alston once needed help minting a batch of silver coins. He employed an accomplice counterfeiter to finish the coining. They traveled to Natchez together and sold the counterfeit coins. As they began their return to Kentucky on the Natchez Trace, Alston told his accomplice that it appeared they were being chased and it would be best if they left the immediate country. They loaded their wagon with bags of good coins and headed west to Spanish Territory.

They traveled until the road became impassable for the wagon. Alston then proposed they divide the money and each take a horse going their separate ways so at least one would escape the authorities chasing them. The accomplice agreed to the plan. Alston took his share of the money to the woods and began digging a hole. The accomplice was naturally curious about what Alston was doing. Alston explained that he intended to only take what money he needed for immediate expenses. He was burying the rest so that his escape wouldn't be impeded by carrying the heavy bags. Alston told the accomplice that he would return in a few weeks when the authorities had given up the chase. It would then be safe to return for the balance of the money. The accomplice considered Alston's plan for a moment and concluded it was a good idea. He decided to do the same thing with his share of the bags of coins.

The two men went their separate ways. Alston rode perhaps ten miles and found a place to lie down and sleep for a few hours. When he awoke, he cautiously returned to the spot where the money had been hidden. The accomplice apparently suspected nothing and was following the agreed-upon plan, as he was nowhere to be seen. Alston dug up both his and the accomplice's stash of the money and never heard from the accomplice again.

Two years later, in 1788, the people of Logan County traced the bogus money to its source and drove Alston out of the community. He settled for a time in the northern part of county in what was known as Alston's Creek, but fearing the people's retribution, he continued north, moving frequently, first to Alston's Lick in what is now Muehlenberg County, then to Livingston County and finally Henderson County, all in Kentucky.

In the early 1790s, he arrived at Red Banks in Henderson County, Kentucky, where several men of dubious character lived on the southern bank of the Ohio River. Alston becomes associated with John Duff at this time. The two crossed the river into the Northwest Territory and began counterfeiting operations at Cave-in-Rock. Philip Alston was probably

the first of the Cave-in-Rock outlaws and the first to bring counterfeiting to the Cave. Duff the Counterfeiter was taught his craft under Alston at the Cave.

Alston didn't stay at Cave-in-Rock long. He returned to Tennessee and made his way back to Natchez. Natchez was now firmly in American hands, but his old enemies, the Spanish, were very receptive to him across the Mississippi River. He was appointed empresido of Mexico. He was tasked with administering land grants in New Madrid (now in Missouri) to new settlers to the Spanish Territory.

It's said that Alston believed in the doctrine of fate and ruled his life by it. He was unusually educated and skilled for a settler in the areas he lived and was often called upon to tutor. He apparently married twice. His first wife was Temperance (Smith) Alston. Her fate is unknown. His second wife was Mildred (McCoy) Alston. Her fate, too, is unknown. Alston had three sons. His son Philip became an Episcopal clergyman. His son John settled in the Northwest and raised a respectable family. His son Peter followed his father's immoral ways and joined Samuel Mason's gang at Cave-in-Rock in the 1790s.

Alston also had two daughters. The aforementioned Frances married James Dromgoole. In 1801, Dromgoole moved to Tennessee and was part of Colbert's Raiders, who pirated the Tennessee and Mississippi Rivers. Alston's other daughter, Elizabeth Elise, married John Gilbert. Alston sold goods to this son-in-law in January 1793.

Philip Alston died in 1794 just as he was beginning to regain his fortune and standing with the Spanish Territorial government.

Author's Note

Philip Alston was a man of firsts. He is the first outlaw associated with Cave-in-Rock. He was the first of the outlaws to bring counterfeiting to the area. Red Banks, Kentucky, was infested with outlaws during the time Alston lived there. It was so bad that the Kentucky government forced law enforcement upon Red Banks because the residents were unable or unwilling to police themselves.

Alston may have been the first of the major outlaws to leave Red Banks for Cave-in-Rock. He also appears to have been one of the first to realize the vulnerability at the Cave and head farther west. His son Peter became

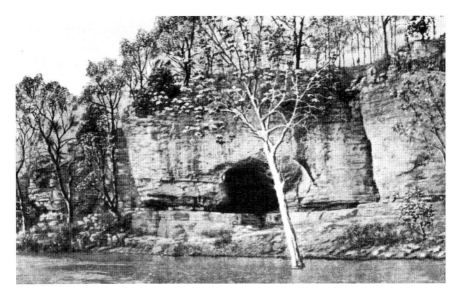

An early postcard from the Cave-in-Rock State Park. This is a print of a photo from the Metcalf Studio. *Courtesy of Jeff Robinson.*

associated with Samuel Mason's gang and possibly figures in the river and land pirate's death.

One account has Philip in Logan County in 1799 proving a deed for John Gilbert. If historian Alex C. Finley is correct that Alston died in 1794, then the Alston who proved the deed may have been his son John McCoy Alston.

DUFF THE COUNTERFEITER

According to some accounts, Duff the Counterfeiter was born John McElduff in South Carolina in either 1759 or 1760. His family moved to Natchez sometime prior to the American Revolution. He's later found at Kaskaskia, the administrative center for the Illinois Territory then under British control.

In 1777, George Rogers Clark was commissioned a lieutenant colonel by Virginia governor Patrick Henry and tasked with capturing the British forts at Kaskaskia and Vincennes in the Illinois Country. Colonel Clark recruited volunteers from surrounding states and began his journey down the Ohio River. In July 1778, Clark found John Duff and a hunting party from Kaskaskia at Fort Massac (now Metropolis, Illinois). From Duff, Colonel Clark discovered that Fort Gage at Kaskaskia was under the command of Lieutenant Governor Philip Rocheblave, a Canadian Frenchman. Rocheblave had a well-organized militia under his command, and he instructed all those living in the territory to report any "Long Knives" (American forces) in the area. Duff may have been using the hunting and fur-trapping expedition to spy for the British.

Under Colonel Clark, Duff's hunting party swore allegiance to America. Colonel Clark took John Saunders, one of Duff's hunting party, as a guide to lead the Long Knives overland to Kaskaskia. Although Saunders lost the trail at least once, Colonel Clark's men successfully surprised the soldiers at Kaskaskia and took the fort without firing a shot. Colonel Clark went on to take the fort at Vincennes (now Indiana), thus taking all of the Illinois Territory from the British.

Duff may have enlisted and served under American forces in the Illinois Territory during the American Revolution. While in Kaskaskia, Duff became acquainted with the brothers of river pirate Samuel Mason and married their sister, Seddy. Duff sold his property and left the Kaskaskia area in 1794.

Duff next appears at Red Banks in Henderson County, Kentucky, then the home of his brother-in-law, Samuel Mason. Duff was introduced to counterfeiter Philip Alston, and the two left Red Banks for Cave-in-Rock. Duff was apparently at Cave-in-Rock with Alston while Mason was still operating out of Red Banks. Duff was taught the art of "making coin" by Alston at the Cave before Alston returned to Natchez and the Spanish Territory beyond the Mississippi River.

Duff made counterfeit coinage, but unlike many of the frontier outlaws, he wasn't a robber or murderer. At least three places were said to be Duff's Fort: Cave-in-Rock; a cabin near Tradewater River (now Caseyville, Kentucky); and Island Ripple (Gallatin County, Illinois), a site on the Saline River about thirteen miles above its mouth with the Ohio River. Both the Saline and Tradewater Rivers are upriver of Cave-in-Rock.

The confusion comes from the fact that Duff is associated with all three places. He learned the counterfeiter's art at the Cave with Alston and apparently operated there briefly during the period of river pirates. Island Ripple is associated with the mine where Duff obtained his metal. Duff's actual home was next to a bluff on the banks of the Ohio River. The cabin was above a swampy slough near the mouth of the Tradewater River. A small meadow on top of the bluff was where he kept his livestock, and the overhanging bluff provided a stable for his horses. Here Duff settled with his wife, Seddy, and his devoted slave, Pompey.

Duff discovered an outcropping of lead ore that contained a good percentage of silver in it at a site on the Saline River in the Illinois Territory. He then melted and separated the lead from the silver and brought the metals back to Kentucky for coining. Duff's coins were so near the genuine articles because he employed a whitesmith named Schammel to prepare the counterfeit molds in fire-clay using impressions from authentic coins. Once the mold was made, the metal was melted down and placed in the mold, making an exact duplicate of the original coin. Duff used three associates to get the coins into circulation. The men were named Blakely, Hazel and Hall.

The counterfeiter was the scourge of honest settlers who could be too easily fooled by the fake coins. One day, an angry group of locals discovered Duff was behind the "coining" and chased him to his cabin. When he

arrived home, he found Seddy washing laundry in a kettle of boiling water in the front yard. Duff kicked the kettle over and used sticks to roll it down to the Ohio River, where it soon cooled enough to touch.

With his pursuers close behind, Duff turned the kettle over, placed it over his head and began wading across the river. Duff's pursuers opened fire, but the shots bounced harmlessly off the iron kettle.

Although the river was low at the time, it eventually became too deep to wade across. Duff used the weight of the kettle to slip under the water and breathe the trapped air inside the kettle. There was just enough air to reach the opposite shore. Once in Illinois Territory, Duff picked up the kettle and held it as a shield to his back. As soon as he was free from the river, his pursuers once again opened fire on him. Duff made it safely to the woods near Battery Rock and escaped.

Another time, Duff was caught out and was about to be captured, but he sought refuge with an old-time Methodist woman named Nancy Hammack. She sheltered him and refused to turn him over to his enemies. Mrs. Hammack treated him so well that Duff offered to give her a glimpse of his treasure. He blindfolded Mrs. Hammack and his own wife and led them in a roundabout way to a cave. By the light of a torch, they saw boxes and chests full of gold and silver coins. Once the ladies' blindfolds were again in place, he led them back to Mrs. Hammack's house. Mrs. Hammack was never again able to find the correct route to Duff's vault but always said the cave was somewhere in the side of a cliff.

Duff was said to have amassed an immense fortune. Mrs. Duff had been blindfolded and taken to the treasure cave one other time by Duff, who promised to show her the way one day. He kept its location a secret even from his own wife for her own protection. He feared if it was known that she knew the location, his enemies would capture her and torture her for the information.

Duff and his associates were causing such a disruption with their counterfeiting that the commander at Fort Massac, Lieutenant Colonel Zebulon Pike Sr., sent troops to capture the outlaws. The soldiers discovered the mine on the Saline River and laid in wait. One morning, Duff, Blakely, Hazel, Hall and Pompey all went to the mine. The soldiers caught them by surprise and captured them.

The prisoners had their hands manacled behind their backs and were placed in a boat for the trip back to Fort Massac. The soldiers falsely assumed Pompey would be eager to be free of Duff's influence and failed to secure his hands as they had the others. During their journey downriver, Pompey

passed a file to Duff. Apparently to pass the time, Duff began to sing loudly as they paddled on the river. In reality, it was to mask the sound as he worked the file against the manacles.

The group traveled down the Saline River to the Ohio River and reached Cave-in-Rock around dinnertime. The soldiers decided to pull the boat to shore in order to light a fire. They left one soldier in charge of the prisoners while the others stacked their firearms and went off to prepare the meal.

One of Duff's men found he was able to slip a hand free of the manacles. Duff himself had also filed his way free. At a signal from Duff, Pompey jumped on the lone sentry and overpowered him. Duff and his associate grabbed the stacked firearms. Without their weapons, the soldiers surrendered. Duff tied the soldiers' hands together so they couldn't free themselves, placed them all in their boat and set it adrift in the river. The soldiers slowly floated downstream while Duff and his associates made it safely back to Kentucky.

When the bound soldiers reached Fort Massac, shots were fired, and they were ordered to pull ashore for inspection. The soldiers were of course powerless to comply and continued to drift. The fort sent a boat out to investigate, and the soldiers were soon free to tell of their encounter with Duff's gang. Colonel Pike was outraged.

A Canadian *coureur de bois* (runner of the woods) had been camping nearby. The commander hired the Canadian and three Shawnee Indians to discover the location of Duff's Fort. The fort was known to be near the mouth of a tributary of the Ohio River. They were instructed to gain Duff's confidence and kill him. If they were successful, they could return to Fort Massac for a reward. Indians were commonly hired to commit these types of deeds in those days.

The Canadian and Indians first went to Lusk's Ferry (now Golconda, Illinois) at the mouth of Lusk Creek. Major James Lusk operated a ferry from Lusk's Ferry Road in Kentucky across the Ohio to a road leading across southern Illinois to Kaskaskia. He had recently moved the ferry operations across the river to Illinois. They loitered around the area for a time, but finding no sign of Duff, they moved on upriver.

The Canadian and Indians found Duff's Fort and camped near the Tradewater River. Duff didn't suspect anything from the new arrivals. He was very friendly with the Canadian, who, in turn, kept delaying the Indians from completing their mission. In time, the Canadian realized he no longer had the desire to finish the job. The Indians, however, became impatient

and told the Canadian they would do it the next day whether the Canadian helped or not.

The Canadian went to warn Duff, who was extremely drunk. Duff grabbed a stick and determined to beat the Indians while they slept. He reached the slough and began crossing it on a log. The Indians, meanwhile, were already on their way, their bodies painted for a fight. Duff reached the other side of the slough and saw the Indians approaching. He called for Pompey to bring his rifle.

Pompey came running to the slough with the gun and jumped in. The Indians were about to take Duff, so Pompey aimed and pulled the trigger on the rifle. In his haste to save his owner, Pompey had splashed water on the rifle. The priming of the gun became wet, and the gun was useless.

Duff fell under the Indians' attack and died. Without Duff's leadership, the gang dispersed. Many have searched around Caseyville, Kentucky, for Duff's treasure cave. If Duff's stash of gold and silver coins were ever found, no one ever claimed they had found it.

Author's Note

There's no proof the John Duff whom George Rogers Clark encountered who operated in and around Kaskaskia is the same Duff the Counterfeiter of the Cave-in-Rock area. Many early historians have made the connection, and the story here is told from that perspective.

According to Governor John Reynolds in *My Own Times* (1855), Duff was killed at Island Ripple by a group of Indians who were hired to commit the murder and buried near the Great Salt Springs in Gallatin County, Illinois. A version of that same story is that the Indians were actually white settlers dressed as Indians. Another account of Duff's death is that local citizens killed him near the bluff where he kept his horses. A third account of his death has it that he was killed by Indians after arguing over a dog fight. Finally, a fourth version, apparently appearing in a newspaper account of the day, has Duff killed at Battery Rock, Illinois, which is directly across the river from Caseyville and was the site of Duff's escape with the iron kettle. Further complicating Duff's demise is the fact that the Daughters of the American Revolution organization has fixed the date of John Duff's death as 1805, while most historians say 1799.

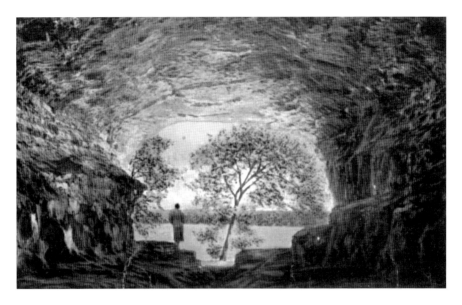

An early postcard from the Cave-in-Rock State Park of the popular silhouette pose. *Courtesy of Jeff Robinson.*

Some historians have placed Duff the Counterfeiter in with the band of outlaws led by the notorious land pirate John A. Murrell. Murrell was born in 1806, after Duff had been eliminated. Also, many histories of the early outlaws around Cave-in-Rock want to associate all of the outlaws together, including making family connections. Folklore states that Duff's wife, Seddy, was Samuel Mason's sister. Mason's actual sister was Rachel Worthington. She married Robert Worthington and died at Cape Girardeau, Missouri, in 1779, prior to the events on Tradewater River.

MICAJAH AND WILEY HARPE

Micajah and Wiley Harpe were either brothers or cousins born in Virginia or North Carolina. Micajah (born 1768) was a tall man with a solid frame and dark, curly hair. He was known as Big Harpe. Wiley (born 1770) had flaming red hair, was slightly smaller in stature and went by Little Harpe. As a rule, the Harpes were well armed with rifles and thick leather belts with pistols, knives and tomahawks.

If they were cousins, their fathers were brothers named Harper who emigrated from Scotland after the uprising of 1745. One of the Harpers could have been the father to both Micajah and Wiley. The Harpers were Tories and were loyal to the British Crown during the American Revolution.

Many accounts have the Harpes fighting at the Battle of Kings Mountain, South Carolina, in 1780, but neither of the Harpes would have been old enough to have been in that battle. It was probably the Loyalist Harper brothers. Because the Harpes fought against the Patriots during the Revolution, Regulators either ran off or killed them after the war. There's no mention of the Harpes' maternity. At the ages of fourteen and twelve, the Harpes may have been fending for themselves. They met two of their "women," the Roberts girls, Susan and Betsy, while they were all still young. It could be the Roberts girls were the daughters of Loyalists and had experienced the same family persecution as the Harpes.

During the Harpes' reign of terror in the 1790s, settlers were afraid to travel. Women and children weren't left alone without protection. No one traveled unarmed. The Harpes were more savage than the other outlaws in

that they killed without robbing or when there wasn't a need. They've been labeled America's first serial killers.

The Harpes used the best horses they could steal and often plunged into the forest to escape pursuit. They were known to frequently change their direction of travel and appear first in one region and then, in short order, be somewhere else entirely, often switching states. They frequently left their women and children behind so their progress wouldn't be slowed.

In the mid-1780s, the Harpes and Roberts left North Carolina and spent time with both the Creek and Cherokee Indian tribes. They lived several years at the Cherokee village at Nickajack on the Tennessee River. The Harpes treated the women very badly. They often accompanied the Indians on raiding parties and would be gone two to three months at a time, leaving the women in the care of the Indians, who treated them more kindly than the Harpes did. They possibly took part in Chief John Watts's raid on Buchanan's Station (Nashville) in September 1792. Captain James Leiper was killed in the raid. He may possibly be related to the John Leiper who would later play a pivotal role in the posse against Micajah. There was speculation that the Harpes and Leiper were well acquainted.

Another man by the name of Moses Doss joined in the Indian raids. He often came to the Roberts women's defense. Micajah considered both Roberts women his wives. Although the Harpes were apparently intimate with both the women, that courtesy did not extend to Doss. In 1794, Moses Doss's mutilated body was found on the road to Nickajack. Micajah had had enough of his interference with the women.

In late 1794, Major James Ore's forces attacked the Nickajack Indian village, driving them from the region. The Harpes somehow learned of the coming attack and hid with their women in a canebrake eight to ten miles from the village. After surviving the assault, they went to the Cumberland Gap and lived there for two years before returning to Tennessee.

In April 1797, a twenty-three-year-old minister by the name of William Lambreth left his home in Virginia intent on traveling to middle Tennessee to form a preaching circuit. Nightfall came, and he stopped to cook his supper and have a campfire to keep wolves away in the night. After his meal, he bedded down for the night near his horse and was soon asleep.

He hadn't slept long when he was awakened by his horse neighing. In the dim light of the fire, he saw a man creeping toward him. Lambreth jumped to his feet, but the man was on him, holding him in an iron grip. Lambreth was told to turn over his horse and money. If he resisted, he would be killed.

Lambreth did as he was told, and as the robber searched him, he found thirty dollars in gold and silver coins in his purse. The robber also found Lambreth's Bible. The man began searching the pages for hidden bills, a common hiding place for keeping currency safe. There he found George Washington's signature in the Bible as well as Lambreth's. Lambreth was asked if he knew Washington. Lambreth told the man they had met in Richmond, Virginia.

The robber then asked Lambreth what he was doing. Lambreth told the robber he was going to begin preaching the gospel in middle Tennessee. The robber then gave the Bible and money back to Lambreth, telling him he would need both the money and the horse where he was going. The robber told Lambreth he was a Harpe and left. Once the Harpes' ravages came to light, Lambreth used the encounter with Micajah in his preaching as an illustration of the "Divine providence of God."

By the summer of 1797, the Harpes and Robertses were living in a cabin on Beaver Creek about eight miles outside Knoxville, Tennessee. They cleared enough land to plant a few acres and built pens for livestock. They engaged in supplying pork and mutton to a merchant in town named John Miller.

Wiley married Sally Rice on June 1, 1797. Sally was the daughter of Reverend John Rice, a Baptist minister who lived about four miles from the Harpes. Micajah married Susan Roberts on September 5, 1797, although he still considered her sister, Betsy, his wife as well.

On market days, the Harpes would bring meat and horses to Knoxville for trade. Over the course of the day, they became drunk, fighting and gambling with the others who had come to the market. One day, they bet heavily on a horse race and lost all the money they had. During a fight with John Bowman, Wiley was cut on the chest. The wound wasn't too severe, but it did leave a scar that would have consequences for Wiley in later years in Mississippi.

John Miller noticed the Harpes seemed to have an abundance of pork. He suspected they were stealing their hogs. He asked around and discovered several farmers in the area were losing their stock, and they all suspected the Harpes. Many accused the Harpes of thievery, but those who did had their houses and barns burned to the ground. Stolen horses were frequently brought to town and sold by the Harpes. One of the horses they had for sale was found to have come from Georgia. It was rumored the Harpes were working with renegade Indians from Nickajack.

The Harpes realized that Knoxville was becoming too hostile toward them and they need to move elsewhere. The women and two pack animals were

scnt ahead to their previous home at Cumberland Gap. It was December 1798, and all three women were pregnant. The Harpes decided to rob one more neighbor before they left the area.

A Knoxville farmer by the name of Edward Tiel discovered his horses had been stolen from their stable. He immediately went to town, and a posse was gathered to go to the Harpes' cabin on Beaver Creek. When they arrived at the cabin, it was apparent the Harpes had left for good. Fortunately for the posse, the Harpes had left an obvious trail away from town. The posse followed the trail and caught the Harpes trying to drive the stolen horses up a mountain pass. The Harpes knew they were overpowered and surrendered without a fight.

Perhaps because of how easily they had captured the Harpes, Tiel's posse was careless with the prisoners and failed to watch and bind them securely. A few miles outside Knoxville, the Harpes saw their chance to escape. They jumped into the thick brambles and undergrowth of the forest and soon disappeared before the posse could react.

Five to six miles north of Knoxville on the Holston River was a roadside tavern owned by a couple named Hughes. Mrs. Hughes's brothers, the Metcalfes, happened to be in town, and a man named D.G. Johnson was there as well. This tavern was a known hangout of the Harpes and had a reputation as a rowdy place.

The evening after the Harpes escaped from Tiel's posse, they surprised everyone by rushing into Hughes's tavern. A fight broke out, with Johnson swinging a large club. When the scuffle was over, Johnson had been dragged off by the Harpes. Two days later, his body was discovered in the Holston River. His abdomen had been sliced open and filled with stones to cause it to sink to the bottom of the river. This would become the Harpes' calling card.

A group of Regulators went to Hughes Tavern and arrested Hughes and the Metcalfe brothers. Hughes told the vigilantes that the Harpes had committed the murder. All were acquitted at trial, but apparently the Hugheses weren't well liked in the community because of their association with the Harpes. The Metcalfes left the area as soon as they were released. The Hugheses reopened their tavern, but it was short-lived. The Regulators returned and tied Mr. Hughes to a tree. Some whipped the man while the others tore the tavern down. After that, Mr. and Mrs. Hughes left the area for good.

After the Hughes raid, the Harpes took the Wilderness Road to rejoin the women at their rendezvous. Near the Cumberland River, they came across a peddler named Peyton. They murdered him by sneaking up behind him.

The Harpes took his horse and picked through his supplies. They left the peddler's lifeless body under branches on the side of the road.

After rejoining the women, the group came upon two men from Maryland named Bates and Paca. Since they were all traveling the Wilderness Road, they decided to travel together. The Marylanders had good horses and rifles. It began to rain, and the travelers huddled together under the forest canopy for shelter. It was beginning to get late, and Micajah suggested they not travel after dark because he had heard the Cherokee were making raids. Bates suggested they make camp there, but Micajah said he knew a place up the road with better water and pasture.

Everyone mounted and started down the trail. Bates and Paca led the way with the Harpes behind them. The women were following about ten yards behind the men. The Harpes silently leveled their guns on the travelers and fired. Micajah killed Bates immediately. Paca survived the bullet, so Wiley used his tomahawk to finish the job.

The Harpes stripped the men of their money and clothes. These were the first good clothes the Harpes had ever owned. The bodies were dragged off the trail and into the underbrush. The Harpes decided to bypass Logan's and Harrod's Stations and made for the Green River area.

Stephen Langford left Virginia for Kentucky using the Wilderness Road. On December 12, 1798, he stopped at John Farris' Inn for breakfast. Farris' Inn was a roadside public house on the Big Rock–Castle River (Mount Vernon, Kentucky today). As the meal was being prepared, the Harpes arrived. Farris offered to feed the two men and three women breakfast as well, but the Harpes refused, saying they lacked the money to pay for it. Langford overheard and, having sympathy for the three pregnant women having to travel in the winter, offered to buy their meal. His offer was accepted, and all were well fed by the Farrises. After breakfast, the group set out together down the road to Green River.

A few days later, a group of men was driving cattle along the same road. The men came to a section of road where the cattle became spooked and scattered. While they were gathering the cattle back together, they found a man's body in the brush. Although the body had been severely battered, he appeared to have died recently. They took the body with them to Big Rock–Castle River. The Farrises recognized Langford and named the Harpes as the probable murderers.

A group of Regulators was organized by Captain Joseph Ballenger, a veteran Indian fighter and local merchant. There had been a heavy snow, which made for a slow pursuit. They found the Harpes camped on Green

River in the wilderness between Crab Orchard and the Cumberland Gap. The Harpes were going to put up a fight until they were told they would be killed if they resisted.

It's thought the Harpes allowed themselves to be captured so the women could deliver their babies in a safe and warm place. The Harpes were arrested on December 25, 1798, and initially taken to Stanford (formerly Logan's Station). When the prisoners were searched, they had linens with Langford's initials and a sack of gold money. One of the shirts they carried had bloodstains on it. A David Irby identified the body. He had been a traveling companion of Langford's before they parted at Farris' Inn.

The hearing at Stanford was held on January 4, 1799. Squires Hugh Logan, Nathan Huston and William Montgomery heard the case. All of the Harpes gave "Roberts" as their last name except Betsy, who called herself Elizabeth Walker. Captain Ballenger testified that Langford's belongings were found with the Harpes. The prisoners pleaded not guilty, and it was decided to send them to Danville, Kentucky, for trial. The sheriff and seven guards left the next day to transfer the prisoners the ten miles to Danville.

While in jail awaiting trial, Micajah gave a challenge to the men of Danville that he would fight the toughest man in town. If Micajah won the fight, he got to go free. If he lost, he would abide by the decision of the court. No one took the challenge.

Betsy Roberts gave birth to a son on February 7, 1799, at the jail in Danville. A month later, on March 7, Susan gave birth to a daughter. On March 16, 1799, Micajah and Wiley Harpe escaped from jail, leaving the three women and two newborns behind. It's not known exactly how the Harpes managed their escape, but the jailer, a man named Biegler, left the job, bought a farm and became one of the more successful farmers of the area.

In April, Sally gave birth to her child. Susan and Betsy's father, "Old Man" Roberts, lived nearby and came to see his daughters. He delivered a note to the women from the Harpes to meet them at Cave-in-Rock when they were set free.

Captain Ballenger was commissioned to recapture the Harpes and given permission to track them into other states. Ballenger's Regulators found the Harpes at Rolling Fork on April 9. The Harpes fired at the group and disappeared into a canebrake. People were starting to feel the Harpes were somewhat supernatural and had powers to cast spells, give an "evil eye" and turn animals rabid. Rumors were spread that they were cannibals. When they fled, no one wanted to risk their life in the canebrake.

One of the Regulators, a frontiersman named Henry Scaggs, suggested letting his dogs track them. He tried recruiting additional men from nearby cabins, but no one wanted to chase the Harpes into the cane.

The next day, thirteen-year-old John Trabue was following the mill path near his home in Adair County, Kentucky, when he met the Harpes. They murdered him and threw his body into a nearby sinkhole. His bones weren't found until several years later. The boy's father was Colonel Daniel Trabue. He had been an officer during the American Revolution. When it was rumored the Harpes had gone to the Cave, Trabue and Scaggs tried to get a Regulator company together without success.

On April 15, 1799, the trial for the Harpe women started under Judges James D. Hunter and Samuel McDowell. Susan was tried first and on April 17 was found guilty of complicity. Both Betsy and Sally were tried the next day and found not guilty. Susan applied for a retrial, but rather than retry her, she was released on the nineteenth.

The residents of Danville felt sorry for the women and their newborns. A collection of supplies was gathered for the women, and they were given a packhorse. The women told the Danville residents they were going back to Knoxville. They traveled thirty miles outside of town then turned toward Green River.

The women traded their horse for a canoe and paddled down Green River to its mouth on the Ohio River in Henderson County. They passed themselves off as widows as they traveled downriver to Red Banks and Diamond Island until finally arriving at the Cave. The women served as "sirens" on the islands and bluffs of the river, helping the river pirates at the Cave capture passing flatboats.

The Harpes killed a man by the name of Dooley near Edmonton, Kentucky. Dooley lived on Big Barren River. The Harpes killed a man's calf and used the hide to fashion moccasins to help them travel faster. They headed to the Little Barren River, where they killed a man named Stump. He lived below Bowling Green, Kentucky, near the mouth of Gasper's River. From there, the Harpes made their way to Cave-in-Rock.

On April 22, 1799, Governor James Gerrard of Kentucky issued a reward of $300 for the death or capture of the Harpes. Captain Ballenger's men gave up the chase and returned home, but a Captain Young organized a group of Regulators from Mercer County, Kentucky. They called themselves the Exterminators. They began in Mercer County, capturing all suspected outlaws. They then crossed Green River and did the same in Henderson County. They drove all the outlaws from Red Banks and Diamond Island. The

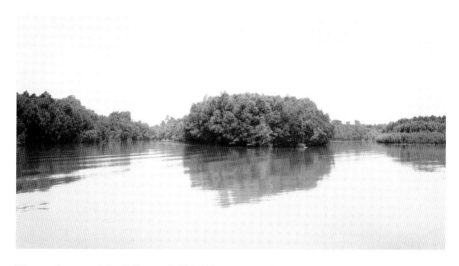

The confluence of the Saline and Ohio Rivers as seen in 1938. On the left of the photo is Hardin County, Illinois. The land in the center is Gallatin County, Illinois. To the right side of the photo is Union County, Kentucky. *Trigg Collection, courtesy of Charles Hammond.*

Cave became crowded with criminals due to the efforts of the Exterminators. Before Captain Young's men were finished, thirteen to fifteen outlaws had been killed, but they never caught the Harpes.

Micajah and Wiley reached the Ohio River and crossed into Illinois near the mouth of the Saline River. Near the future site of Potts' Spring the Harpes killed three men around their campfire. Two were shot. The third man lost his life to a tomahawk. From there, the Harpes rejoined the women at the Cave at Cave-in-Rock.

A flatboat traveling down the Ohio River required some repairs. The boatmen pulled ashore at Cedar Point just upriver of the Cave. A young couple on board decided to climb the bluff to pass the time. While they were admiring the view of Kentucky across the river, the Harpes snuck up behind the couple and pushed them over the bluff. Amazingly, they survived the fall and returned to the flatboat. The crew quickly left before any other danger befell them.

Two families of settlers set out on a flatboat on the Ohio River bound for Smithland, Kentucky. They were lured ashore by the river pirates, and all but the captain were murdered. At nightfall, the pirates were in the Cave celebrating their latest robbery. A huge fire was lit at the mouth of the Cave where all the outlaws had gathered. The Harpes took the flatboat captain to the bluff above the Cave. The captain was stripped naked and bound to a blindfolded horse. The Harpes led the horse to a position where he was

pointed toward the bluff. The horse was then prodded and took off at a full gallop toward the bluff. Horse and rider went over the bluff, fell one hundred feet and landed on the rocks below in front of the celebrating river pirates.

Even for the murderous river pirates, this cruelty was too much. The Harpes were told they had to leave. They and their women left the Cave in late May and headed back to Kentucky. They floated down the Ohio River and entered the Tennessee River near present-day Paducah, Kentucky.

The Harpes passed into Tennessee near Fort Blunt. They killed a man named Bradbury about twenty-five miles northwest of Knoxville. They also killed a small girl near her house. When the girl's body was discovered, a Captain Bedford and six soldiers on horseback searched for the murderers. They chased the Harpes back into Kentucky. Near Mammoth Cave, Bedford lost all trace of the Harpes. After searching for two fruitless days, Bedford's group returned to Tennessee. The Harpes hid for two to three weeks in the caverns and then returned to Tennessee.

The Harpes killed a man named Hardin. On July 22, 1799, Isaac Coffee was traveling by horseback to pick up a fiddle. He was the thirteen-year-old son of Chelsey Coffee. Eight miles from Knoxville, the Harpes came upon him and smashed his head against a tree. The Harpes took his gun and shoes.

Two days later, the Harpes killed William Ballard. They filled his body with rocks and threw it in a river. On July 29, the Harpes come upon James and Robert Brassel in Morgan County, Tennessee, at a place that came to be known as Brassel's Knob. James was on foot and Robert was on horseback. The Harpes attacked James. Robert jumped from his horse to help his brother. When Robert realized he was going to be overpowered, he ran to get help.

Robert gathered several men together and returned to the spot, where they found James lying on the ground. His head was smashed, and his gun was broken in pieces beside him. They followed the trail toward Knoxville. Brassel's posse met a group coming from the opposite direction. There were two men and three women all on horseback with two pack animals. They had found the Harpes, but the posse only had one gun, so they let them pass unharmed. Brassel's group then acquired firearms for everyone and resumed their pursuit.

In early August, the Harpes killed John Tully. Nathaniel Stockton organized a group to search for Tully's murderer. Stockton's group met up with Brassel's group. Most of the members of the posse from Tennessee returned to their homes. A man named Wood from Brassel's group and

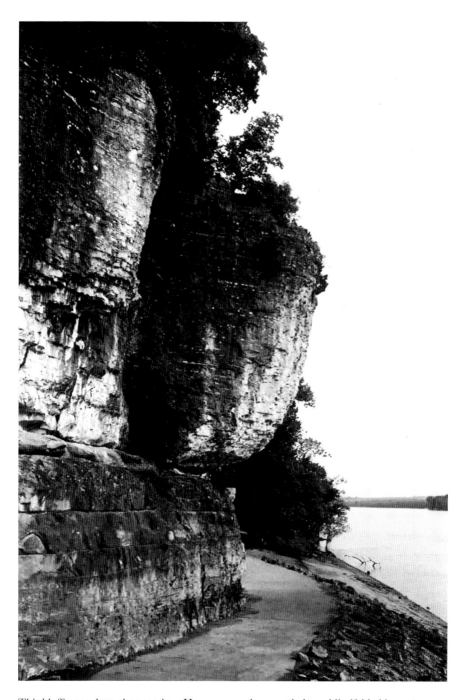

This bluff was where the notorious Harpes caused a man tied to a blindfolded horse to plunge to their deaths below. This incident caused the river pirates to banish the Harpes from the Cave. *Author's collection.*

Stockton decided to go warn Colonel Trabue that the Harpes were again in the area. Trabue sent a message to General Samuel Hopkins at Red Banks, and a messenger named John Ellis was sent to the state capital in Frankfort.

For two weeks, the Harpes lived in a cave eight miles west of Russellville. They hunted by day and caused mischief by night. While the Harpes were hunting, they discovered two Trisword brothers and their families and slaves camping nearby at Claylick Woods. The Harpes decided to kill the entire party and head back to the Ohio River and make for Stack Island on the Mississippi River.

Two Cherokee may have been with the Harpes when they attacked the Trisword family. At daybreak, they killed all but one of the brothers, who managed to escape and ran the eight miles to Dromgoole's Station (now Adairville, Kentucky). Colonel William Stewart, the sheriff of Logan County, organized a company of nine men to return to the Triswords' camp. It was presumed to be an Indian attack.

When the posse arrived at the camp, there were dead bodies everywhere. Many were stripped bare, and several had been mangled. The posse dug a single deep grave and buried the entire family and their slaves together. It was decided the Harpes were behind the brutal murders. It appeared they left by the Buffalo Trace. Steward gathered ten to twelve men and went in pursuit.

The first night out from the Trisword massacre, the Harpes camped at the site of a recently concluded camp meeting. Reverends John and William McBee and Reverend James M'Gready had held the tent meetings on the banks of the Mud River. While still in the Russellville area, Sally's nine-month-old newborn was sick and had been crying all morning. Micajah was afraid the crying infant would give away their position to the men following them. Often, the women slept away from the men to protect the children. Micajah had no patience with crying infants. When Sally was unable to calm the baby, Micajah grabbed the child by the ankles and beat it repeatedly against a nearby tree. When the baby was bludgeoned to death, Micajah flung the child as far as he could into the woods, and they left that place.

The Harpes arrived at John Graves's cabin and asked permission to camp overnight. Graves granted their request. In the middle of the night, the Harpes killed Graves and his thirteen-year-old son with Graves's own axe. The Harpes next visited "Old Man" Roberts. While in the area, a young girl was horrifically killed. A young black boy was going to the mill with corn. The Harpes beat his head against a tree until his skull was crushed. They didn't even steal the boy's horse or grain.

The Harpes reached Henderson County and rented a cabin on Canoe Creek near Knob Lick. The Harpes sent the women and children ahead to their next meeting place. Moses Stegall met the women on his way to Robinson's Lick to acquire some salt. The Stegall family was familiar with the Harpes. He told the women that they could get the dollar that he owed them from his wife.

The Harpe women lost their way and stopped at John Leiper's house on August 16 asking for directions to Stegall's house. Leiper put them on the right trail, and they found Mary Stegall at home. When Mrs. Stegall paid the women the dollar they were owed, the Harpe women saw forty dollars in silver coins. They retraced their steps and told the Harpes what they found before continuing on their way to the next rendezvous.

A hunter and former Indian fighter, John Slover, was returning from Robertson's Lick when he heard the unmistakable click of a gun misfiring. Turning, he saw two fierce-looking men approaching him, so he hurriedly galloped away and warned all the neighbors what had happened. Up to that point, no one thought the Harpes were in the area. A man named Towbridge was returning from the lick with his salt. The Harpes killed him, dumping his body in Highland Creek.

General Hopkins at Red Banks had been warned by Colonel Trabue that the Harpes were again in the area. When he heard the report of the murders and Slover's report of being fired upon, General Hopkins suspected the settlers on Canoe Creek were the Harpes. He sent some of his men to spy on the cabin. The Harpes knew they were being watched and didn't do anything suspicious. Since the women and children weren't with them, the spies mistakenly assumed Micajah and Wiley weren't the Harpes and left.

The Harpes traveled to Deer Creek near Steuben's Lick where James Tomkins lived. On August 21, 1799, they were invited to have dinner with Tomkins. The Harpes claimed to be Methodist ministers. Tomkins asked Micajah to pray, which he did, and the men discussed the game in the area over dinner. Tomkins told his guests there were plenty of deer, but he didn't have venison because he was out of powder. Micajah pulled out his power horn and handed Tomkins a teacup of powder. Micajah would regret that gift in the coming days.

The Harpes' next target was a justice of the peace in the area named Silas McBee. They left Tomkins and traveled the four miles to McBee's house. They were chased away when McBee's dogs warned of their presence. They traveled on to spend the night at Moses Stegall's cabin. Stegall was still away collecting salt.

Mary Stegall told the Harpes she had an overnight guest sleeping in the loft, surveyor Major William Love. Even though she knew Micajah and Wiley, she was instructed to pretend they were Methodist ministers. During the night, the Harpes killed Major Love with a tomahawk, supposedly because of his snoring. The next morning, they asked Mrs. Stegall for breakfast. She was busy with her fussy four-month-old son. Micajah offered to watch the baby while she cooked. Mary was pleased that the baby's crying ended soon after Micajah started babysitting.

When breakfast was ready, Micajah and Wiley sat down to eat. Mary went to her baby and was horrified to find Micajah had slit the baby's throat. The Harpes killed Mary by stabbing her repeatedly with knives. When she was found, three knives were still in her, plunged to the hilt. The Harpes grabbed some of the clothes and bedding and then kicked over the cookstove to catch the house on fire. They hoped McBee would come investigate the fire, and they planned to ambush him on the trail.

Two men were attracted to the fire and came to investigate with their dogs. The men were named Gilmore and Hudgins. They had been to Robertson's Lick gathering salt. Micajah and Wiley confronted the men on the trail. They accused Gilmore and Hudgins of being the Harpes and setting fire to Stegall's cabin. At this point, the Harpes hatched a new plan of taking the men to McBee's house, thinking that with his guard down, they could kill him. Gilmore and Hudgins both ran. Gilmore was killed immediately. Hudgins was overtaken and killed before he could escape too far. The Harpes kept the dogs, thinking they might prove useful. They then resumed their hidden ambush position on the trail.

John Pyles and four other men saw the Stegall house on fire and immediately went to McBee's to report it. McBee enlisted the aid of a neighbor, William Grissom. They used a shortcut to go to Stegall's cabin and avoided the Harpes' ambush. By the time they arrived, the cabin was nothing but smoldering remains. When McBee and Grissom examined the wreckage, they found the ghastly bodies.

After the bodies had been buried, they returned to McBee's house by the shortcut, completely foiling the Harpes' ambush. Moses Stegall arrived at McBee's about the same time McBee and Grissom were returning. Stegall was told what had happened to his family. He decided to go to Robertson's Lick to recruit help for a posse. The date was August 22, 1799.

In the meantime, the Harpes had met their women at the rendezvous with the loot from the Stegall house. Micajah was now riding Major Love's horse, which was a good steed. They now all had good horses and

enough pack animals to haul their belongings to join Mississippi River gangs.

The following men formed the posse to track down the Harpes: John Leiper, James Tomkins, Silas McBee, Neville Lindsey, Matthew Christian, William Grissom and Moses Stegall. Leiper agreed to kill Micajah while Stegall agreed to kill Wiley. The others served as backup. They rode all that day and came to a place where a herd of bison had been. The Harpes had frightened the bison, causing the animals to scatter. The Harpes hoped the various trails of tracks would mask their own, but the posse picked out the Harpes' route and followed it until nightfall. The posse camped on the western bank of Pond River having not seen the Harpes all that day.

The posse resumed the chase at dawn. An hour later, they found the remains of Gilmore and Hudgins's dogs. They hadn't been dead long. Leiper, Stegall, Christian and Lindsey dismounted and began walking so as to surprise the Harpes. The others followed behind with the horses. A mile farther on, they saw three men on the next hillside.

The Harpes had made their camp the previous night at a stone formation with a rock overhang that offered some protection in case of attack. The dogs were eliminated so they wouldn't give them away. Micajah suggested they kill the children to free them to travel faster. An argument ensued. Sally was especially devastated, having lost her own baby just weeks before. She decided to take the children and hide under the sheltering rock, using her own body as a shield.

Wiley came to Sally under the rock overhang to tell her they'd decided to kill the children. He saw a man on a hillside nearby and went to confront him. The man told Wiley his name was George Smith and he was out hunting for wild horses. Wiley blew his charger as a signal to Micajah to join him. Micajah rode up on Major Love's gray mare, his rifle in his hand. The Harpes accused Smith of being a horse thief, and Micajah told Smith he was going to kill him. This is when the posse arrived.

Smith saw the posse and began running toward them. Wiley jumped into a nearby canebrake and ran for cover. Micajah, still on horseback, turned around and left at a full gallop. The posse thought Smith was one of the Harpes, and McBee shot at him. Smith was hit in the right arm. He may have been hit in the thigh as well. Stegall recognized Smith as one of the men from that area and called for a ceasefire, saving the man's life.

The posse gathered around the wounded Smith, who told his story. They then followed the direction Micajah went and found Sally with the children at the Harpes' camp. She pointed in the direction Micajah had gone with

his wives. McBee and Smith took charge of Sally and the children while the others continued the chase.

About two miles farther, the posse caught up to Micajah and the two sisters. Four of the men fired. Christian's shot hit Micajah in the thigh. He abandoned the women and galloped off toward Pond River. The ramrod to Leiper's gun had become fouled, and he couldn't reload. Tomkins still had a shot in his rifle and was riding the best horse. He and Leiper exchanged mounts and guns so Leiper could continue the chase. Tomkins and Lindsey stayed with the Roberts sisters and waited on Smith and McBee to catch up to them. Grissom, Christian and Stegall resumed the chase, trying to keep up with Leiper on the thoroughbred.

Micajah came to a downed poplar tree too tall to jump near the river. The riverbank was too steep to go down, so he doubled back and met Leiper. The outlaw was told to surrender. Micajah yelled, "Never!" and again plunged through the undergrowth to try to escape. Leiper continued the chase, gaining on Micajah. Leiper again called for the outlaw to halt or be killed. Micajah suddenly stopped the horse and brought his rifle around at Leiper. The gun jammed, and Micajah threw the useless rifle to the ground.

With Micajah's sudden halt, Leiper quickly gained on him and saw a chance to fire. Leiper stopped his horse and leveled Tomkins's gun at Micajah. Using the outlaw's own powder he'd given Tomkins just days before, Leiper took careful aim. Micajah immediately brought his horse around to resume his escape. Leiper fired and hit Micajah square in the middle of his back. Micajah had enough strength to again urge his horse to continue on.

The rest of the posse caught up to Leiper and joined him in the pursuit. Micajah was struggling to hold on. He reached for his tomahawk but couldn't lift it. The posse caught him and told him to surrender. Micajah told the posse he would if they quit chasing him. They agreed and dismounted. Micajah saw his last chance to escape. He again plunged his horse into a nearby canebrake. Leiper's horse was startled by Micajah's action and ran off. Christian galloped after the horse and returned it to Leiper. The posse followed Micajah into the canebrake. They didn't go far before they came to the horse grazing. Micajah was barely hanging onto the saddle. Leiper rode next to the outlaw and pulled him from the mount. The outlaw was nearly paralyzed from the neck down from Leiper's shot through his spine.

McBee and Smith arrived, having left all the women and children with Tomkins and Lindsey at the Harpes' camp. Micajah begged to be taken prisoner and tried in a court of law. Leiper examined the wound in the outlaw's back and told him it was fatal. Micajah asked for water. Either a

hat or a boot was filled with water from the nearby Pond River and given to Micajah. McBee asked him if he had anything to confess. He implicated a man named Baldwin who lived at Green Tree Grove. That man was later tried and acquitted of any wrongdoing associated with the Harpes. In his last moments, Micajah confessed to about twenty murders and said his only regret was the killing of Sally's baby.

The men asked him if he had money hidden. Micajah told them that he had money stashed in saddlebags about twenty miles from the mouth of Pond River. No one ever found the money, and it was thought to be a lie Micajah told to delay his execution. Micajah was told they would give him time to pray, but he refused the offer. Stegall leaned down and told Micajah he was going to cut off his head.

After about an hour's rest, Stegall went to Micajah and put his rifle against the man's head. Micajah kept moving his head back and forth to delay the inevitable. Stegall became frustrated and shot the outlaw through the heart. He died instantly. Stegall then kept his promise and cut Micajah's head from his body. Some accounts claim Stegall did the deed while Micajah was still alive and talking to him, but in McBee's own account of the incident, he says Stegall shot Micajah first. Micajah Harpe was executed and beheaded on August 24, 1799.

The head was put in McBee's satchel, and the body was left lying on the ground where he'd fallen off the horse. The posse returned to Tomkins and Lindsey at the Harpes' camp. When they had rejoined the women, Stegall noticed that Susan Harpe was wearing one of his wife's dresses. Stegall became enraged and tried to kill her but was held back by Leiper and McBee. The posse took their prisoners to Red Banks.

The summer heat was quickly putrefying the head, and the group decided they could no longer travel with it. At an intersection of the roads from Henderson, Morganfield and Hopkinsville, a small tree was stripped of its branches and the trunk sharpened into a spike. Micajah's head was placed on that spike, where the bleached skull remained for many years. An alternate version says that it was placed in the fork of an oak tree. That intersection came to be known as Harpe's Head Road and is still known as that today.

The women had an initial hearing at Red Banks on September 4, 1799, when it was decided to send them to Russellville for trial. They left Henderson County two days later for the ninety-five-mile trip. They arrived in Russellville on September 28. Sheriff Stewart gave the women liberty around town if they promised not to escape. He brought a spinning wheel and supplies to the jail to give them something to occupy their time.

Stegall arrived with a group to murder the women. Judge Ormsby was afraid the women would be lynched, so he had Sheriff Stewart jail them for their own safety.

Stewart decided to move the women out of town. In the middle of the night, they were taken to a nearby sink. The next night, he sent them to a cave five miles outside town, where they were provided food. Stegall's group searched Logan County for several days looking for the women and then left.

A grand jury convened on October 28. Each of the women had her own jury hear the case. The trial was held on October 29 and 30. The women were tried as Susanna Harpe, Betsy Roberts and Sally Harpe. The women said the Harpes had been falsely accused and jailed while they were at Knoxville. When they were released, they decided all of mankind was their enemy, and the two determined to rob and murder until they were dead. The women were found not guilty and released.

Susan Harpe and her daughter, Lovey, went to live on the plantation of Colonel Anthony Butler. She made her living spinning and weaving. Lovey was said to have had too much of her father in her. She left the area and settled in Perak, Mississippi, and was never heard of again. Betsy Roberts married John Huffstutler. Her son went by the name of Jon Roberts and enlisted in the army. Sally Rice wrote to her father, Reverend John Rice. He retrieved his daughter and brought her back to the Knoxville area. She remarried and traveled through the Cave-in-Rock area again when her family crossed the Ohio River by ferry on their move to Illinois.

On December 16, 1799, the Kentucky state legislature approved the payment of the reward authorized by Governor Gerrard the previous April. As the one who gave Micajah Harpe the fatal wound, John Leiper was awarded $100. The other six men of the posse shared the remaining $200 of the reward money.

In 1806, Moses Stegall eloped to Illinois with a Miss Maddox. They made their home in a cabin where Potts' Inn would later be located. Maddox's father, brother and Peak Fletcher searched until they found the couple. Stegall and Joshua Fleehart were sitting around a lamp under a galley outside the cabin. Maddox was sitting on Stegall's lap. One of the men shot Stegall, and they returned the girl to Kentucky.

Wiley Harpe hid in the canebrake until the posse had left. He made his way to the Ohio River near the mouth of the Tradewater River. He found a pirogue tied there and stole it. Wiley rejoined the river pirates at the Cave. After Captain Young's Exterminator raids, the river pirates felt vulnerable at Cave-in-Rock. Samuel Mason reasoned that it was easier to let the settlers

take the cargo to Natchez or New Orleans rather than send river pirates to do it. Most of the river pirates abandoned the Cave and moved operations on the Mississippi River and the Natchez Trace to catch the settlers on their return to Kentucky, Tennessee, Indiana and Ohio. Historians have noted that the murders associated with Samuel Mason seemed to increase when Wiley Harpe joined his gang. (See chapter 4 on Samuel Mason.)

Author's Note

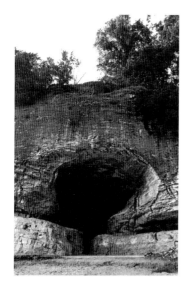

The river pirates were celebrating around a huge bonfire at the entrance of the Cave when the Harpes ran a blindfolded horse and flatboat captain off the bluff above. *Author's collection.*

Sharon Q. Huffstutler O'Neal in *Springhouse* 6, no. 4 (August 1989) found through genealogy research that she was a descendent of Micajah Harpe's "supplemental wife," Betsy Roberts, from her marriage to John Huffstutler in 1803. When she researched her husband's ancestors, she found he was descended from William Love. So the descendant of Micajah Harpe's supplemental wife married the descendant of one of Micajah Harpe's last victims 190 years later. Truth is indeed stranger than fiction (or folklore).

Rather than joining the river pirates at Cave-in-Rock in 1799, the Harpes probably left Kentucky for Tennessee in the late spring of 1799. Other than local legend, there's no actual evidence the Harpes were ever at Cave-in-Rock. I've mostly followed the timeline of events in the Harpes' rampage across Kentucky and Tennessee developed by E. Don Harpe as published in *Springhouse* 23, no. 2.

T. Marshall Smith's *Legends of the War of Independence* (1855) lists many events and facts about the Harpes that are contrary to others. One fact mentioned by Smith is that numerous children were sired by the Harpes over the years as they traveled with the women. In each case, the children were murdered by the Harpes. Most historians only tell of the three who are mentioned in this story.

SAMUEL MASON

Samuel Mason was one of the most successful of the frontier outlaws. He was born about 1750 in Virginia. He was described as a rough and burly man, but his most distinguishing feature was a tooth that stuck out, a "wolf fang" that could only be covered with his lip with effort.

Two of his brothers, Thomas and Joseph, started west with Colonel George Rogers Clark's expedition in 1778 to claim the Illinois Territory from the British. Mason himself served in the defense of the upper Ohio River Valley during the American Revolution, earning the rank of captain.

At Fort Henry near what is now Wheeling, West Virginia, Mason was wounded in an ambush by Indians. He escaped with his life by hiding behind a fallen tree trunk. Mason was twice mentioned for bravery in battling hostile Indians. He continued to serve at Fort Henry until 1779. He also served as a militia captain in Ohio County, Virginia, until at least 1781.

In 1780, he was keeping a roadside tavern two miles east of what is now Wheeling, West Virginia. Two years after the end of the Revolution, he left the Wheeling area. It's been suggested that horses were coming up missing, and Mason was often connected.

Mason next appears in eastern Tennessee staying in cabins owned by General John Sevier of Washington County. Items began to turn up missing from the slave quarters on Sundays while the occupants were off to church. A thorough search was conducted, and several of the stolen items were found in the possession of Mason and his friends. General Sevier forced Mason and his associates from the area.

In 1781, Mason and his family settled on the Red River south of Russellville, Kentucky. His youngest son was born here in 1787. In 1790, Mason was one of the signers of the petition to form Logan County, Kentucky.

In the 1790s, all the horse thieves and outlaws of the area seemed to gather on the banks of the Ohio River at Red Banks (now Henderson, Kentucky). Mason was one of the first outlaws who murdered for money and profit, but unlike the Harpes, he was more careful with corpses. At Red Banks, he helped establish the local government and served as a justice of the peace.

Mason and his family were some of the first settlers in that region of Kentucky. His family at Red Banks consisted of his wife, four sons and a daughter. Duff the Counterfeiter was said to have married Mason's sister. Other members of Mason's gang included a Tennessean named Henry Harvard; a tavern keeper, Nicholas Welsh; and two others named Barrett and Hewitt.

In an effort to bring a sense of law and order to Henderson County, Captain John Dunn was appointed the first constable in 1792. He suspected Mason's gang of thievery and refused to sign legal papers for Mason. In retaliation, Mason's gang beat Dunn to near death; in time, he recovered.

Mason's daughter started dating a man named Kuykendall, an outlaw himself who operated out of Diamond Island downriver from Red Banks. Kuykendall was said to carry "Devil Claws": metal strips that slipped over a fighter's fingers that eviscerated an opponent's face when drawn across his skin. Mason didn't care for the courtship and refused to allow Kuykendall into his home. It's said Mason's daughter smuggled her love interest to her bedroom by hiding him under her petticoats each evening and morning.

Kuykendall and Elizabeth Mason eloped to Diamond Island. Mason went to the couple under the guise of making peace. He invited them to come back to Red Banks for a wedding celebration. That evening, there was much dancing and partying with the couple. When Kuykendall left the festivities to return to Diamond Island, he was killed by a shot from a rifle. Elizabeth later married a man named Thompson and lived in Cape Girardeau, Missouri.

While living at Red Banks, Mason stole Hugh Knox's female slave and her two children. Knox went to Captain Dunn, and they rode to Mason's house and recovered the slave and her children. Mason's gang cornered Knox and beat him. In later years, Hugh Knox became a judge in Henderson County.

About 1797, Mason's family left Red Banks for Diamond Island. That fall, Thomas Mason came back to Red Banks. He had been drinking and began

to threaten Captain Dunn's life. Mrs. Dunn sent Thomas Durbin, one of Dunn's cousins, to talk to Thomas and try to convince him to spare Dunn's life. Thomas shot and killed Durbin and then fled Red Banks.

Later that year, Captain Dunn and Thomas Smith went to Knob Lick to trade cornmeal for salt. While crossing the ford of Canoe Creek, Captain Dunn was shot by Henry Harvard. Smith took Dunn home, where he died a few hours later. Harvard immediately left the Henderson County area. A group of Regulators was organized to hunt down Harvard. He was found at his father's house on the Red River in Tennessee. The group shot and killed him while he was hiding between feather mattresses on a bed.

Hewitt was caught by the group of Regulators but was let go and told to leave the country when the group determined he wasn't responsible for Dunn's death. Welsh, the tavern keeper at Red Banks, was probably an informer for Mason's gang and a fence for selling stolen goods. He left the area and was never heard of again.

It was after Constable Dunn's killing in 1797 that Mason moved his operations down to Cave-in-Rock. It is said that a sign was placed at the water's edge near the cave that advertised "Wilson's Liquor Vault and House for Entertainment." Mason is also said to have adopted an alias of Jim Wilson. Many unsuspecting boatmen were guests at Wilson's Tavern.

Mason fitted out the Cave as a dwelling and tavern and surrounded himself with a band of robbers and cutthroats. It's said there were up to forty-five men operating between Cave-in-Rock and Hurricane Island just a few miles downstream. Mason's older sons joined him in his exploits at the Cave.

There were many snags, hidden rocks and sandbars in the river between Diamond Island and Hurricane Island. Often, men would be stationed upstream on the islands or prominent bluffs like Battery Rock or Tower Rock to offer assistance to novice boatmen navigating the serpentine channel. Another ploy was to use "boat wreckers." A gang member would use some ploy to get aboard a boat. The wrecker would then bore a hole in the boat or remove chinking from the planks so that the boat would begin to sink near where the wrecker's associates were waiting. The crew would land the boat to prevent its sinking and would be captured.

Sometimes women were placed on the islands to lure men on flatboats to shore. They would beg to be rescued from a "shipwreck" and taken to a settlement downstream. Often, they would ask to be taken to Cave-in-Rock where other members of their party were. Of course, the pirates would ambush them as soon as they landed at the Cave. Another ploy was

Right: The Cave was several feet away from the Ohio River prior to the installation of dams to raise the river level for year-round navigation. Trees and bushes partially obscured the entrance, making it appear even more foreboding. *Trigg Collection, courtesy of Charles Hammond*.

Below: Tower Rock is one of the highest points on the Ohio River. From this vantage point, river pirates could see boats from miles upstream. The site is now a recreational area of the Shawnee National Forest. *Author's collection*.

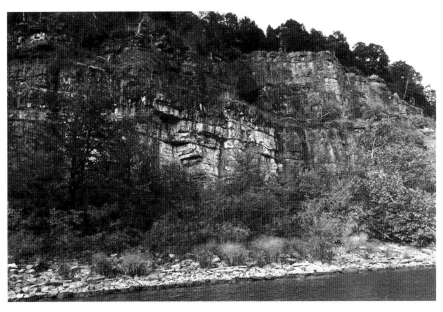

51

The head of Hurricane Island in the Ohio River across from Tower Rock. This two-mile-long island was the last chain in Samuel Mason's river pirate operation of capturing passing flatboats. It was later owned by James Ford, who used it to farm and store stolen livestock. *Trigg Collection, courtesy of Charles Hammond.*

to seek supplies such as meal or bacon that were lacking at the Cave from passing flatboats.

What boats weren't taken at the Cave were captured downstream at Hurricane Island. Whole crews of boats that landed were murdered, and the boats were fitted out with new crews from Mason's gang. The boats were then taken down the Ohio to the Mississippi River and on to Natchez or New Orleans, where the cargos were sold. Because months passed from the time boats left the upper Ohio River to their expected return, often there was no trace of the long-dead crews by the time anyone searched their route looking for them.

The Harpe women were said to have arrived at Red Banks in 1799 and then moved downriver to the Cave to wait for Big and Little Harpe to rejoin them. When the women were with the Mason gang, they were used as "sirens" to lure the passing flatboats to shore.

James May arrived in Red Banks with a woman reported to be his sister. While at Red Banks, May stole some horses and he and his "sister" left town. They were overtaken at Vincennes, Indiana, and brought back to Henderson County and jailed. That same night, he escaped by what was described as an "extraordinary jump." May made his way downriver and joined Mason's gang at Cave-in-Rock.

Mason was a land and river pirate. He plundered boats descending the Ohio River but found it easier to let them pass and plunder the owners of their cargo's profits on their return by way of the Natchez Trace. Mason began moving operations farther downstream to Wolf Island south of the confluence of the Ohio and Mississippi Rivers. Another factor in the move was the pirate crews Mason put in charge of captured vessels often stayed in Natchez and spent the money they earned off the cargo instead of returning to Cave-in-Rock.

Mason left Red Banks before justice could be served. He left Diamond Island ahead of Captain Young's Regulators, the Exterminators, when they cleared Henderson County of outlaws. Mason also anticipated Cave-in-Rock would be their next target. By the time missing boatmen and cargoes brought Regulators to Cave-in-Rock, Mason had already moved south in either late 1799 or early 1800.

We next find Mason at New Madrid in 1800 applying for a passport to settle in the Spanish Territory west of the Mississippi River in what is now Missouri. Mason lived in the Spanish Territory and robbed Americans or river travelers. By avoiding conflicts with the Spanish, Mason thought he was safe.

John Swaney was the mail carrier between Natchez and Nashville. The round trip took three weeks with a full rest day on each end of the route. He carried a horn he would blow to let highwaymen and Indians know that it was him on the trail. Both let him travel unmolested.

Swaney witnessed a robbery and murder by Mason. The murdered man was Robert McAlpin from the Carolinas, who was traveling the Natchez Trace with his son and a Major Ellis. Swaney came upon the murder scene and led McAlpin's traveling companions to an Indian village, Pigeon Roost, for help. Mason never robbed Swaney because he knew it was a federal offense and would bring federal forces against him.

Mason settled at New Prairie (now Caruthersville, Missouri) and had two outposts. One was Stack Island, fifty miles above Walnut Hills (now Vicksburg, Mississippi). The other was at Rocky Springs on the Natchez Trace. Mason's two oldest sons accompanied him to the Mississippi River, as did John Setton and James May.

One day, Mason's gang startled a group from Kentucky returning home on the Natchez Trace. They were camping for the night with one of the men posted as guard. As he was walking along the perimeter, he tripped over one of Mason's men sneaking into the campsite. The gang member fired a shot, which scattered the half-dressed Kentuckians into the woods.

Mason's gang robbed Colonel Joshua Baker on August 14, 1801. Colonel Baker, William Baker and a man named Rogers had sold a group of horses and mules and were returning to Kentucky along the Natchez Trace. They came to a crossing over a creek with steep banks and a deep cut that led to a ford across the creek. That creek is now known as Baker's Creek. As they went through the narrow access to the creek, they heard the command to surrender by four men whose faces had been blackened with charcoal to disguise their appearance. Colonel Baker and his companions were robbed at gunpoint.

Colonel Baker's party traveled to the nearest settlement for help and immediately began a chase of the robbers. They pursued the outlaws to the Pearl River. Here the posse stopped at noon to eat and cool themselves with a swim in the river. Some of the party swam close to the opposite shore and were captured stark naked by the outlaw gang. Mason yelled across the river to Baker and ordered him to throw all their weapons and ammunition on the riverbank or the captured men would be killed. Colonel Baker's party complied with Mason's orders, and two gang members traveled across the river to retrieve the weapons. The robbers left and let the captured men go unharmed.

A merchant by the name of Anthony Glass owned a general store in Natchez. Mason disposed of his stolen goods through Glass's store and connections. One day, Mason and his son John were arrested for robbery while visiting Glass. The Masons were tied to a post, stripped of their shirts and given lashes with a whip.

After the whipping, Mason threatened the crowd and was placed in jail. A trial was held, with one juror in particular calling for the Masons to hang. Mason's gang helped them escape before they could be sentenced. This same juror was stopped by Mason while traveling outside town. Mason commanded the man to get off his horse. He asked the juror what harm he or his son had ever done to him. The man confessed that neither had ever harmed him. Mason told him he had five minutes to pray before he shot him in the head. While the man was praying, Mason slipped away.

In 1801, Colonel Baker led a flatboat of goods down the Mississippi River. He came prepared for an ambush by arming the boatmen. River pirates from Stack Island met the flatboat and were fought off by Colonel Baker and his men. When he reached Natchez, Colonel Baker filed a complaint. Baker's report reached the Mississippi Territorial governor, William C.C. Claiborne.

On February 10, 1802, Governor Claiborne sent a correspondence to his Spanish counterpart at New Orleans, Manuel de Salcedo, concerning the river piracy. They agreed to work together to end the menace. Secretary of War Henry Dearborn contributed $400 and Governor Claiborne provided an additional $500 as reward for the capture of Samuel Mason and his gang. On April 27, 1802, Governor Claiborne sent letters to three different military outposts calling for the arrest and capture of Mason and Wiley Harpe. It was rumored that Wiley had reappeared as part of Mason's gang operating on the Mississippi River and the Natchez Trace.

The province of Louisiana was transferred from the French to the Spanish in 1762. Spain transferred the same territory back to France on September 1, 1800, but France didn't take possession until November 30, 1803. Seven months before, on April 30, 1803, Napoleon had sold the territory to the United States as part of the Louisiana Purchase. The transfer of the lower territory happened on December 20, 1803, in New Orleans. The upper territory, which included New Madrid, didn't occur until March 9, 1804, in St. Louis.

On October 15, 1802, New Madrid changed to French control. In January 1803, Mason moved his family and followers across the Mississippi River to Little Prairie in the former Spanish Territory. French officials at

New Madrid received a report that eight men and one woman believed to be Mason's gang had taken residence in Little Prairie on a twenty-acre plot of land.

Captain Henri Peyroux sent Captain McCoy with troops to arrest Mason's gang. When they arrived in Little Prairie, McCoy found Mason with a saddled horse getting ready to escape. Mason told McCoy that he looked forward to going to New Madrid and clearing his name. McCoy gathered all of Mason's gang in one location, surrounded them with his soldiers and had the gang arrested and shackled before they knew what happened.

The militia arrested the following gang members: Samuel Mason; his sons Thomas, John, eighteen-year-old Samuel Jr. and sixteen-year-old Magnus; John's wife, Marguerita (Douglas) Mason, and her three children; and John Taylor, who at the trial revealed his name was John Setton.

Mason and family were brought to New Madrid on January 16, 1803. Their trial began the next day. Mason declared that he was innocent of all the accusations that had been made against him and claimed that if given enough time he could prove he wasn't the person responsible for the crimes. He turned over the Spanish passport he had received to prove he had the right to settle in New Prairie. The French officials told Mason that Colonel Baker was coming to testify, and Mason became increasingly uneasy with the proceedings.

When John Setton was arrested, he gave his name as John Taylor. As he gave his testimony, he again stated his name was Taylor. Mason told officials he had planned to spend the rest of his life on Spanish soil and under no circumstances did he want to be turned over to the Americans. He then testified that John Taylor was an alias for John Setton, and it was Setton who was guilty of the crimes, not Mason.

Setton returned to testify and admitted to using the Taylor alias. He said Mason had demanded he give the false identity. Setton stated he'd only been with Mason since the previous May, or only eight months, and couldn't have been guilty of the acts going back three years. Setton declared that he was actually Mason's prisoner because he was made to sign a confession to crimes committed by Mason's gang. Mason used the signed confession as leverage against Setton. In Setton's testimony, he implicated Mason and his sons in several crimes.

On January 20, 1803, Mason was again on the witness stand to testify and answer the allegations brought against him by Setton. All of the family testified, including Mason's sons and John Mason's wife. The family's testimony mostly matched the statements made by Mason. The gang's

belongings had been brought from New Prairie as evidence. The court examined the various items and determined their value. Of particular interest was the presence of about twenty human scalps and over $7,000 in various currencies, some counterfeit.

Before the trial ended, Francois Derousser of New Madrid came forward and said when he had traveled west, he had been falsely accused of being a horse thief by Mason at Red Banks. He then worked for Mason for two months before continuing on his journey. When he left, he was robbed by Mason.

Peyroux determined Mason and his group hadn't committed crimes in the French Territory, but they had done enough on American soil to be conveyed to the Spanish officials at New Orleans, who had the power to extradite them to American officials. Peyroux decided to not try them further but to move them downriver to New Orleans.

New Madrid to New Orleans was a two-week trip by boat, which was far quicker than the overland route. In February 1803, Captain McCoy left with the prisoners for New Orleans. There were seventeen on board: the seven prisoners and three children, five guards who also served as the boat's crew, Captain McCoy and an interpreter. It was expected that Setton would testify on behalf of the prosecution and Mason would be convicted of several crimes.

The Spanish official at New Orleans, Manuel de Salcedo, received the prisoners and the report from New Madrid. Salcedo decided to send the prisoners on to his American counterpart in Natchez so Mason's gang could be tried on American soil. A sailboat was secured to convey the prisoners back up the Mississippi River.

On the journey back up the river, the mast broke, and the boat had to be brought to shore to secure a new one. While most of the crew/guards were ashore cutting the new mast, Mason's gang overpowered a guard and made their escape. This was on March 26, 1803. Captain McCoy received gunshot wounds to his shoulder and chest. McCoy returned fire at Mason, giving him a glancing wound above his eye. Both men recovered from their wounds.

Sometime after the escape, James May rejoined Mason's gang. Governor Claiborne offered a new reward of $1,000 for Mason's capture—dead or alive. Mason was seen two months later north of Natchez on the Choctaw Trace near Cole's Creek. Two detachments of militia were sent after them, but the gang escaped.

In July 1803, James May tried to collect the reward by saying he'd shot and killed Mason. To prove he had executed Mason, May produced stolen money and described the wound above Mason's eye. May was denied the

reward for lack of evidence that Mason was truly dead. May then joined forces with John Setton. While on horseback, they robbed two men on the Natchez Trace. One of the men was killed, but the other escaped.

Setton and May then robbed Elisha Winters, who was on his way to New Orleans. Winters escaped with his life and made his way to Natchez. In October 1803, Winters saw Setton and May and had them arrested. The gang members told authorities they could eliminate Mason if they were released. The officials decided to accept their offer and released them in November. Setton and May found Mason at one of his hideouts and rejoined his gang.

In late November or early December, Setton and May found themselves alone with Mason. They shot him and used a tomahawk to decapitate him. They returned to Natchez with the evidence that Mason had been killed and to claim their reward. Mason's wife had been living separately from him for some time, trying to live an honest life. She was brought from her home at Bayou Pierre, Louisiana, to verify the head was that of her husband. She denied it was him. Several other witnesses, however, verified the head belonged to Samuel Mason. The presence of the "wolf fang" and wound above his eye led officials to believe that the head truly belonged to Samuel Mason.

Setton and May went to Governor Claiborne to collect their reward. The governor told them the local treasury was currently too low, but he was expecting a shipment of money in a few days that would allow him to settle with them. Since they would be in town for a few days, they quartered their horses at a local tavern and made accommodations for themselves. The man who had escaped death at the hands of Setton and May two months before on the Natchez Trace arrived in town and was putting his horse to stable when he noticed a horse with a particular blaze on its face. It was the very horse of one of the men who had robbed him and killed his companion. An inquiry with the tavern keeper revealed the owner to be one of the men collecting the reward for Mason's death. In fact, they were at the courthouse at that very hour.

Captain Frederick Stump brought a military garrison to Natchez as part of the Louisiana Purchase transfer. Governor Claiborne invited Stump to stay with him, and he was present when Setton and May arrived to collect the reward. The man who had been robbed also arrived at the courthouse and confronted Setton and May. Since there wasn't any evidence to present other than the horse's particular blaze, Governor Claiborne couldn't justify arresting them. Captain Stump had been observing the proceedings

and found something very familiar about John Setton. Stump informed Governor Claiborne that he was sure Setton was in fact Wiley Harpe. The governor had heard the rumors that Wiley was part of Mason's gang and had included that fact in the dispatches he'd sent to the local garrisons the previous year. Setton and May were immediately arrested.

An announcement went out throughout the city for anyone with knowledge of Wiley Harpe to come forward. At the Natchez dockyard, five Kentuckians had just sold a flatboat of cargo. The boatmen had seen the Harpes when they were being held in the Danville, Kentucky jail awaiting trial. The Kentuckians came forward and reported that Wiley had a mole on his neck and two of his toes were grown together. Setton was found to have both identifying marks.

Also in Natchez was John Bowman from Knoxville, Tennessee. He claimed that he and Wiley had a disagreement in Knoxville several years before that led to a knife fight. He told the authorities if Setton was Wiley Harpe, there should be a scar on the left side of his chest from a knife wound Bowman had inflicted on him. Setton's shirt was ripped open, and there was the scar Bowman had reported.

Both were lodged in the Natchez jail awaiting trial. Setton, who had already been caught using the John Taylor alias, continued to deny that he was Wiley Harpe. Somehow, both men escaped custody and fled into the country. Everyone in the immediate area was on high alert for the outlaws, determined that they should be found.

About twenty miles away near Old Greenville (not to be confused with the current town of Greenville, Mississippi), Setton and May were recaptured and tried under separate juries. Elisha Winters was brought in as a witness at the trial. Setton and May were indicted on armed robbery before Judges Peter B. Bruin, David Ker and Thomas Rodney. Ker died shortly after the trial, but Bruin and Rodney were the judges who would later hear Aaron Burr's treason case before that trial was moved to Virginia.

May was found guilty first, followed by Setton. They were sentenced on February 4, 1804, and executed by hanging on February 8, 1804. At the gallows, May stated he had rendered the country a great service by eliminating the threat of Samuel Mason. He said he didn't deserve what fate had wrought on him. Setton continued to deny that he was Wiley Harpe and implicated several people currently not known to be connected with Mason.

When they were dead, a man took their bodies down from the gallows and beheaded them. One head was placed on the trace north of town while the other was placed south as a warning to all highwaymen of what fate

awaited outlaws. The headless bodies were buried in a cemetery beside the Natchez Trace. Locals who had family buried in the cemetery were said to have exhumed the bodies of their loved ones and moved them elsewhere to avoid lying for eternity next to the notorious robbers.

Author's Note

It was suggested by Finley that Peter Alston, son of counterfeiter Philip Alston, was hanged with Little Harpe for killing Samuel Mason. If this is true, one reason there is little record of James May before his association with Mason is that May was an alias for Peter Alston. No other historian of the era, however, seems to have made that connection.

Wagner and McCorvie make a good point that Setton was tried in federal court as John Setton, and in correspondence written after the trial, both the presiding judge Thomas Rodney and Governor Claiborne referred to him as John Setton, not Wiley Harpe. This connection and the previously mentioned Alston/May alias may again be attempts to more closely connect all the outlaws with one another. Although the folklore tales list several "proofs" used to confirm John Setton was Wiley Harpe, there are also cases where people familiar with Wiley Harpe came forward to deny that it was him. Also, as mentioned in the Harpe chapter, there's no record the Harpes or their women were ever at Cave-in-Rock, although we have tales of their exploits there.

Many histories of the Cave mention the sign on the river's edge touting "Wilson's Liquor Vault and House for Entertainment," as well as the Samuel Mason alias Jim Wilson. This was first mentioned by Thomas Ashe in *Travels in America in 1806* (1808). Wagner and McCorvie have pointed out that several of the natural features Ashe writes about are obvious fabrications that don't fit the features of the area. It's entirely possible that he fictionalized events as well in order to sensationalize or "fill gaps" in his knowledge of what he was writing about. His writings have been picked up and perpetuated by other writers of the era and continue to be told today. What Wagner and McCorvie do state is that of all the river pirates of the 1790–1800 era, Samuel Mason is the only one who has proof that he actually operated out of Cave-in-Rock.

Early land records show a "squatter" named James Wilson lived on the bluff of present-day Elizabethtown, Illinois, about 1807. The cabin said to

The "Mystery Cabin of Hardin County" is now on display at the Saline Creek Pioneer Village in Harrisburg, Illinois. This cabin is said to have been built by Jim Wilson, an early 1800s squatter in Hardin County and possibly a river pirate. *Author's collection.*

be his has been removed to the Saline Creek Pioneer Village in Harrisburg, Illinois, where it has been restored and is on display. This was the oldest structure in Hardin County. A sign refers to it as the mystery cabin and possible home of a river pirate. Could this factual James Wilson have been the proprietor of Wilson's Liquor Vault and House for Entertainment, or could it be an unfortunate coincidence?

It's been said that Samuel Mason's brother Isaac married Catherine Harrison, the sister of Benjamin Harrison VI and President William Henry Harrison. However, Benjamin and William Harrison didn't have a sister named Catherine.

ROSWELL AND MERRICK STURDIVANT

Roswell S. and Merrick Sturdivant were brother counterfeiters who operated in and around Cave-in-Rock. They were members of a crime family that stretched back three generations. Some of their family were said to have served during the American Revolutionary War. These brothers started their counterfeiting enterprise during the War of 1812 in Delaware County, Ohio, using salt boring as a cover for the illegal activities. The locals discovered what the brothers were doing, and they had to leave the area.

The Sturdivants claimed to have come from Robinson (Robertson) County, Tennessee. They were in Illinois by 1818, as they were included in the statehood census. In 1819, Merrick Sturdivant was arrested in Golconda, Illinois, for passing counterfeit currency. In his arrest, he stated his residence was Manville Ferry (now New Athens, Illinois). In the 1820 census, Roswell Sturdivant is listed in St. Clair County, Illinois.

During the early days of Illinois settlement, counterfeiting became a great burden on the settlers and early trade. In January 1816, the Illinois territorial government set the penalty for anyone found guilty of counterfeiting as death by hanging without the benefit of clergy.

By the time of statehood in 1818, Illinois had softened the penalty to $500 and seventy-five lashes with a whip. The same penalty was in place for manufacturing or carrying paper into the state for the purpose of counterfeiting or for possessing engraving plates. The penalty for passing counterfeit currency was similar: $500 and thirty-nine lashes. If the fine wasn't paid, the guilty party could be sold into indentured servitude for a

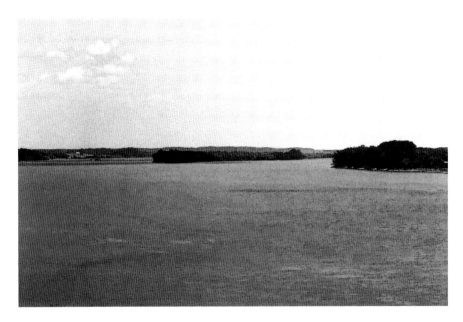

The view of the Ohio River from Sturdivant's Fort. The foot of Hurricane Island is in the middle of the picture with present-day Elizabethtown, Illinois, on the left side. *Author's collection.*

period of seven years. In 1821, the manufacture of gold and silver counterfeit coins was added to the law.

Sturdivant's Fort stood on a high cliff on the Illinois shore of the Ohio River in what is today the city of Rosiclare. The fort had a commanding view of the foot of Hurricane Island and traffic coming down the river. McFarlan's Ferry (now Elizabethtown, Illinois) was just two miles upriver and within view of Sturdivant's home.

Sturdivant's home and farm was said to be one of the best in this part of the country. The structure was at least one and a half stories and possibly two stories tall. The main building measured sixty feet square. The first floor consisted of three rooms to each side with a four-foot central hallway running the length of the building. From each of the corners, a one-hundred-foot corridor led to what were probably two-story frontier blockhouses on each corner. A wooden palisade surrounded the entire compound.

Roswell Sturdivant was said to be a quiet and inoffensive man. He was widely known as a mechanical genius and a superior engraver. He was paid five dollars to engrave the Pope County Circuit Court seal in March 1821. The portion of Hardin County where Sturdivant's Fort was located was

part of Pope County when the Sturdivants operated there. The Sturdivants weren't violent people, but many of their associates were.

Roswell carried a horn or bugle with him at all times. He maintained close friendships with all of his neighbors. Many who lived in the area were actually members of his gang. At the blowing of his horn, Roswell had a group of up to fifty men ready to reinforce and defend the fort. Roswell Sturdivant didn't bother his neighbors, so he had few local enemies. In fact, many reputable people in the county were supportive of him. This is evidenced by his commission to engrave the court seal.

There are two phases to a counterfeiting operation. The first phase is the actual production of the currency. The Sturdivants performed their engraving and printing at the fort. The second phase is the distribution of the currency. Sturdivant used the Cave nine miles upstream of the fort as a sort of exchange bank.

Members of Sturdivant's gang were scattered throughout the region. They returned often to the Cave for regular supplies of counterfeit notes. The exchange rate used was $100 in counterfeit bills for $16 of legal currency. In

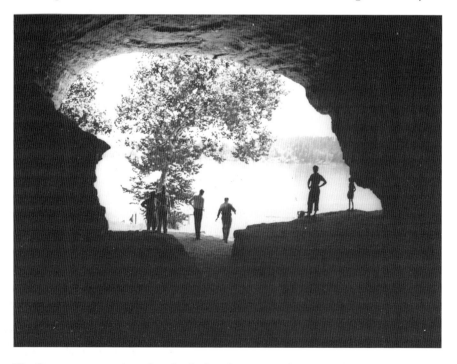

The Cave was a convenient place for the Sturdivants to exchange genuine money for fake currency away from where the actual counterfeit bills were manufactured. *Trigg Collection, courtesy of Charles Hammond.*

this way, the Sturdivants became some of the most notorious counterfeiters in the region. They became a nuisance that had to be dealt with because of the sheer amount of fake money they put into circulation.

In 1820, some members of the Sturdivant gang were in Shawneetown, Illinois. They were caught passing the fake money and arrested. Shawneetown attorney John McLean prosecuted the men. In one of the men's pocketbook was a note that implicated Merrick Sturdivant. Later that same year, McLean began serving his first term in the Illinois House of Representatives serving as the Speaker of the House.

The year 1820 also brought James Hall to Shawneetown. Hall wrote several early histories of the frontier area. Hall bought a half interest in a local newspaper, the *Illinois Times*, and entered into a partnership with attorney Henry Eddy. Eddy was the prosecuting attorney for six southern Illinois counties, including Pope County, where the Sturdivants lived, and Gallatin County, where Shawneetown was located.

On December 29, 1821, Shawneetown's John Marshall Bank, the first bank in the state of Illinois, received a letter from Roswell Sturdivant warning the bank that counterfeit currency was being passed in the area. The best guess is that Roswell thought that by sending the warning, suspicion would be drawn away from him.

By April of the following year, more counterfeit notes were being circulated in Shawneetown. In June, another of Sturdivant's gang members was caught and arrested with the fake currency. Hall took four men and traveled to Golconda, Illinois, to capture the Sturdivants and bring them to Shawneetown for trial.

When Hall reached Golconda, he was able to add a constable and four other citizens to his group. Sturdivant's Fort was ten miles north of Golconda. When they arrived at the fort, two men crept inside the compound. When they were able to enter undetected, the rest of Hall's party quickly pressed in and took the six or seven gang members by surprise. Both Roswell and Merrick were at the fort.

Although he had been surprised by the raid, Roswell had the opportunity to blow his horn and call for reinforcements. Hall quickly searched the compound. The upper chamber of the fort was full of work benches and every tool needed to engrave plates for counterfeiting. Hall also found pigments and inks for printing the bills.

Since the alarm had been given and reinforcements were coming to help the Sturdivants, Hall's raiding party of eight to ten men left the fort with only the two brothers in custody. They hurriedly rode back toward Shawneetown,

followed closely by nine members of Sturdivant's gang. At sundown, Hall's group reached Potts' Inn, where they stopped for the night. Sturdivant's gang was reinforced with an additional twelve who surrounded the inn and threatened to attack. The standoff lasted throughout the night.

There's no record of why, but by the next morning, the gang had withdrawn from the inn, and Hall's group traveled to Shawneetown with the Sturdivants without incident. In their haste to escape from Sturdivant's Fort, Hall's party had failed to collect any of the engraving tools, pigments or ink. Due to a lack of any physical evidence of criminal activity, the prosecutor was forced to let the Sturdivants go free from custody.

Roswell Sturdivant returned to his bluff-top fort and went back to business as usual. His confederates continued to trade legal tender for the counterfeit money, spreading it up and down the rivers and roads to communities throughout the region. In May 1823, a group of attorneys, justices of the peace and constables from the surrounding counties formed a Regulator raiding party to drive the Sturdivants from their fort for good.

A group of eighteen to twenty men gathered in Golconda and set out for Sturdivant's Fort. They attacked the fort and were repelled by the gang. One of the raiding party, a man by the name of Small, was killed in the assault. Sturdivant had added a small cannon to his defense arsenal since the raid the previous year. The men retreated back to Golconda for reinforcements.

Two days later, forty men set out again to raid Sturdivant's Fort. The steamboat *Cincinnati* transported the group free of charge. When they arrived at the fort, Reverend Rondeau, a minister from Golconda, tried to get the gang to surrender without resistance. Rondeau was shot in the shoulder in reply.

When the final assault was over, Mr. Small was the only death among the raiding party. Three members of the gang were killed. Roswell Sturdivant suffered a serious wound to the neck but recovered over time. Roswell Sturdivant; his father, Azor; and William Caldwell were all charged with assault and battery in addition to the counterfeiting operations. The *Cincinnati* transported the party back to Shawneetown and Golconda after the raid.

On May 15, 1823, Samuel O'Melveny and Alexander Parkinson, early pioneers in Pope County history, paid the $400 bond for Roswell Sturdivant's bail. O'Melveny went on to serve in the state legislature and participated in the writing of the first Illinois constitution. In an ironic twist, John McLean, the attorney who prosecuted the gang in 1820, was hired to defend the Sturdivants and Caldwell. McLean used legal maneuvers to get the case continued several times. Azor Sturdivant died in April 1824 while still awaiting trial.

Eventually, McLean's efforts caused the case to be removed from the docket altogether. McLean never received payment for his services and sued Sturdivant. McLean died in 1830 having never collected on the debt. There's no evidence that Roswell Sturdivant and William Caldwell were ever convicted and punished for their crimes.

Roswell Sturdivant escaped justice in Illinois. He and his confederates were driven from the community by the Regulator Company. In 1876, when some quarrying was going on near the old fort site, a previously hidden hollow in the stone was opened. Dies and counterfeiting equipment were supposedly found inside the rock crevice.

Roswell next appears in Natchez, Mississippi, operating a gambling den in a section of the city called Natchez Under the Hill. This area included the wharf area of the river and was the southern terminus of the Natchez Trace. Roswell, going by the name "Black Jack" Sturdivant, had apparently quit counterfeiting and was now a cardsharp gambler and local gangster.

In 1829, a John Lattimore brought the family's cotton harvest to the Natchez wharf to sell. A buyer was found, and Lattimore found himself with a pocket full of money. He went to Sturdivant's tavern, had a drink and played some hands of cards. Before he left, Sturdivant had fleeced him of all the proceeds of the cotton sale.

Leaving the tavern, Lattimore walked the streets of Natchez, wondering what he was going to do and how he would possibly explain what happened to his family back home. He was in this depressed condition when he came across a friend of his father, famous frontiersman Jim Bowie. Lattimore shared with Bowie what had happened. Bowie offered to return to the tavern with Lattimore.

Bowie started observing a card game that Sturdivant was engaged in. It wasn't long before Bowie discovered that Sturdivant was cheating. Bowie walked to the gambler's table and picked up enough money off the table to cover Lattimore's losses. Sturdivant rose to his feet wanting to fight, which Bowie was more than happy to do.

Bowie and Sturdivant each had one of their wrists bound to the other and wielded a knife in their free hand. A ten-foot chalk circle was drawn on the floor for the fighting arena. At a signal, the fight began, with Sturdivant taking the first slash at Bowie. Sturdivant missed, but Bowie's return jab cut Sturdivant's arm to the bone, causing him to drop his knife. The fight was over in seconds. Bowie cut the binding on their wrists, releasing Sturdivant from the fight. Bowie refused to kill an unarmed man.

Bowie and Lattimore left the tavern with the money unmolested. Lattimore returned to the family farm having learned a valuable lesson from Sturdivant's tavern at Natchez Under the Hill. The following year, Jim Bowie left for Texas, where he participated in the Texas Revolution, dying at the Battle of the Alamo.

Author's Note

Historians Ronald Nelson and Gary DeNeal used land records to find the general location of Sturdivant's Fort, as they reported in *Springhouse* 15, no. 2 (April 1998). With the permission of the then current landowner, they used dowsing rods and flagging to find the original layout of Sturdivant's Fort. The fort site is in the backyard of private property within the city limits of Rosiclare.

According to these same land records, Roswell Sturdivant bought the land where the fort sat on November 17, 1820, for $2,000 under a contract for deed. After the attacks, Samuel O'Melveny (who helped provide Sturdivant's bail) claimed he had purchased the property from Roswell on October 7, 1820, for $1,000. The claim was signed by Roswell, Merrick and James Steele. The claim by O'Melveny makes it appear Roswell sold the land before he actually owned it.

JAMES FORD

James N. Ford was born in South Carolina on October 22, 1775, during the latter part of the American Revolution. He left South Carolina with his stepfather, William Prince, and family, traveling first to Tennessee in 1795 and then later to Kentucky. In 1797, Ford settled in the Cave-in-Rock area. For the rest of his life, he lived on either the Illinois or Kentucky side of the Ohio River in the vicinity of the Cave.

Ford was undoubtedly familiar with the exploits of the river pirates operating from the Cave in the 1790s, but history shows no connection between Ford and Philip Alston, John Duff, Samuel Mason or the Harpe brothers. Sturdivant's Fort was either on or near property James Ford had once owned. They may have been more than passing acquaintances. From 1799 to 1802, Ford was a member of the Cavalry of Livingston County Regiment, in which he served as captain.

James Ford married Susan Miles in 1798 or 1799. She was the daughter of Richard Miles, who operated a ferry near present-day Rosiclare, Illinois. This is the first ferry that Ford became associated with but isn't the Ford's Ferry (or Ferry Ohio) that has become infamous. During this time, Ford began acquiring property and slaves in Illinois and Kentucky and began farming operations, including farming the large Hurricane Island on the Ohio River. His son Phillip was born in 1800, and another son, William, followed in 1804. A daughter, Cassandra, was born one or two years later.

In 1800, Ford was one of three persons appointed to survey and construct a road to Miles' Ferry. In 1804, he was involved in surveying a road to

Lusk's Ferry at Golconda. In 1803, he became a justice of the peace, a position he held on numerous occasions in his lifetime, both in Illinois and Kentucky. He was often called upon to appraise and administer estates. For all outward appearances, Ford was an extremely community-minded settler who worked to fashion western Kentucky and southern Illinois into states with thriving communities.

About a mile inland from the head of Hurricane Island near present-day Tolu, Kentucky, Ford built a two-story home on a five-hundred-acre plantation. Ford's home was about five miles below Cave-in-Rock and eight miles below the site of Ford's Ferry. Ford used his role as justice of the peace to legally obtain the plunder his gang acquired from the passing settlers. Any goods or livestock "found" was recorded in the Livingston County Stray Book. A valuation was also recorded. If the owner didn't claim the stray goods or livestock by a certain date, it became the property of the finder. As justice of the peace, Ford oversaw an unusually large amount of "found" property. His sons also have numerous listings.

In 1800, Ford didn't have a single property listing in Livingston County, Kentucky. By 1804, he listed 200 acres, two slaves and two horses. Over the next several years, he continued to add to his holdings and began listing property in all three of his children's names even though they were all underage. In 1810, ten-year-old Phillip had three parcels in his name, two of which were 200 acres each. In 1818, Ford had 851 acres. For several years, he's listed as having twenty slaves and eight horses, but he probably had many more of each.

On May 5, 1817, James Ewing of Vincennes, Indiana, hired Charles Fleister, Joel Potter and James Donnell to pilot a flatboat of cargo for sale. The cargo was valued at $2,000 and was to be received by Benjamin Morgan in New Orleans, Louisiana.

At Shawneetown, Illinois, on May 14, Donnell tried to sell the boat and cargo. Fleister was able to convince him that they should continue downriver with the cargo to the intended recipient. They pushed off from Shawneetown and rounded the bend toward Cave-in-Rock. Somewhere between the Cave and Hurricane Island, the flatboat hit a sandbar and became wedged.

A Captain Trimble came along and offered to help get the boat off the sandbar and floating again. During the operations to free the boat, several pieces of the cargo became damaged and the roof of the boat came loose. When it was free from the obstacle, Trimble conducted them to the riverbank close to Ford's house. He told the three boatmen that Ford would buy their boat and cargo. Trimble was given twenty bushels of corn from the cargo

for his assistance. Ford came down to the riverside and invited the men to breakfast the next morning.

At breakfast, Ford served a strong drink, and Donnell became drunk. Ford led him outside. After a while, Ford came back in and told Fleister that he had bought both boat and cargo. Fleister told Ford that Donnell couldn't sell him the cargo, as it was the property of James Ewing and they had to present the goods to Benjamin Morgan in Louisiana. Fleister showed letters to that effect to Ford.

Ford pretended to be illiterate and unable to read the letter. He instructed his slaves to begin unloading the shipment and transfer it to the house in an ox cart. Fleister insisted the cargo couldn't be sold. He kept objecting until Ford threatened to beat him. Finally, Ford offered to pay Fleister what was to be received in New Orleans, and Fleister was made to sign a receipt.

Months passed, and word reached Ewing that the shipment had never arrived in New Orleans. He sent his agent, Charles Pentland, to investigate. At Shawneetown, Pentland found Fleister, who told him he had received $59 from Ford and Donnell had received an additional $190 for Ewing's cargo. Pentland demanded the money and sued him for it. Pentland then traveled to Livingston County to Ford himself. Ford showed him the receipt and offered to give up the boat and goods if Ewing would pay what he had given for it. By this time, both the flatboat and the cargo were long gone from his possession.

Ewing filed suit in July 1817 against Ford for misappropriation of goods and property. Ford brought various witnesses to the trial to prove that all was done above board, and he legally had rights to the cargo. Judge Benjamin Shackleford then gave odd instructions to the jury members before they went to deliberation. The jurors were instructed that if they felt that Ewing had brought suit against Fleister for the money Ford paid for the cargo, then they should rule in favor of the defendant. Apparently, the judge was leading the jury to believe that since Ewing had attempted to recover the money paid for the goods, Ford's role in the matter shouldn't be considered.

The jury found in favor of the prosecution, Ewing, and awarded him $200, which was about 10 percent of the total value of the cargo. Ewing asked for a retrial. Judge Shackleford overruled and let the ruling stand.

Ewing then took the case to the court of appeals in its 1819 term. The lower court's ruling was reversed due to the strange jury instructions given by the judge. The case was also moved out of Livingston County to Caldwell County. The case was to be heard on September 27, 1821. Ewing didn't come to court. There's no record of why, and the case was dropped.

In 1822, Charles Webb graduated from medical school and with his brother, John, decided to leave their home in South Carolina and head west to make their fortune. Their destination was St. Louis. They traveled to Philadelphia, Pennsylvania, and from there Pittsburgh, where they were able to hire on to a flatboat headed to Louisville, Kentucky. In Louisville, they met Jonathan Lumley, who was taking a broadhorn flatboat to New Orleans. They were offered the same opportunity, so Dr. Webb and John joined the crew, and the five set off down the Ohio River.

Dr. Webb was a proficient flute player and entertained the men as they traveled. The cargo consisted mainly of corn and whiskey with a few other provisions. The Webbs intended to work their passage to the mouth of the Ohio River and then travel up the Mississippi River to their final destination of St. Louis.

As they traveled past the limestone bluffs on the north side of the river, they saw a woman on the bluff waving a white cloth and yelling for them to pull closer to shore. Lumley came within hailing distance, and a man stepped out of the Cave and asked them if they had any bacon or whiskey to trade. Lumley said they did, but he didn't want to break up the cargo this early in the trip. Prices would be better the closer they got to New Orleans.

The man then told him a woman and her son were staying at the Cave looking for passage downriver to the mouth of the Cumberland River. He told Lumley they would pay for the trip. Lumley realized his boat would be passing that way anyway, and the chance to earn a bit more money for their trouble was too great a deal to pass up. Lumley landed the boat two hundred yards downriver of the Cave.

Lumley, John Webb and a boatman went to the Cave to assist the passengers. After about an hour, the other boatman went to see what was taking so long. He didn't return either. Dr. Webb was left alone with the broadhorn and cargo. At dark, he saw three men approaching. He thought they were the crew returning and was ready to give them a piece of his mind when he saw the approaching men all had pistols in their hands.

Dr. Webb was told that his companions were okay, but if he made a sound, he'd be killed. Dr. Webb asked about his brother and was told the fewer questions he asked the better it would be for him. He was bound and blindfolded. They searched his clothes and took all his valuables, including his flute. He was put into a nearby skiff and rowed out into the middle of the river.

He felt the skiff bump another boat. One of his captors leaned close and told him that he was supposed to be killed, but if he would float away

without making a sound, they would let him live. The binding on his wrists was loosened, and the skiff floated away. Dr. Webb lay silently in the bottom of the boat and listened for sounds of the robbers. He didn't dare move for fear the other boat was still somewhere nearby.

After about an hour, he worked his hands loose and removed the blindfold. He was floating in the middle of the river. No lights could be seen on either shore. He searched the boat and didn't have an oar. He decided to wait for morning and see what daylight brought him.

Off in the distance, he heard the rumble of thunder. Lightning soon followed, and the wind picked up. The river had been calm up to this point, but waves started lapping against the sides, tossing the boat about. All at once, the sky opened up with a downpour of rain.

Dr. Webb found the boat filling with water, and there wasn't a cup or pail to be found. He removed a shoe and used it to bail water from the boat. By morning, he was exhausted but still floating. He was approaching an island in the river, and smoke was rising from the treetops. He leaned over the side and used his hands to paddle the skiff to shore.

On the island, he found the cabin of a Mr. and Mrs. Prior. He told them what had happened and how he was worried for his brother's safety. While Mrs. Prior prepared breakfast, Mr. Prior used a clapboard to make an oar. The Priors instructed him to continue downstream and land at Smithland, Kentucky, near the mouth of the Cumberland River. He would be able to find help there.

Dr. Webb followed the advice he received from the Priors and soon reached Smithland. He told officials there what had happened at the Cave and his concern for his brother's welfare. He was warned that the gang at Cave-in-Rock was rumored to be associated with James Ford. He was given a horse and told to ride to Salem, Kentucky, to seek advice from Judge Dixon Given. Judge Given told him to go see Colonel Arthur Love, who would accompany him to Ford's residence, where he could ask about his brother.

Dr. Webb took off on the road to Colonel Love's. As he was traveling, something frightened his horse, and it bolted at a full gallop. Webb was thrown from the horse and landed awkwardly on his feet and severely injured his ankle. He was despairing over what to do when a lady came along and offered to give him a ride to her home. The lady was Cassandra Ford, James Ford's daughter.

Dr. Webb was in the home a week before he met James Ford himself, who offered to let Dr. Webb convalesce there. One day, Cassandra was showing Dr. Webb some of the things her father had gotten her when she brought

out a flute. It was the very flute that was stolen the night he was robbed at the Cave. Webb stayed several days until he was able to walk with a pair of crutches. He also took his flute.

Dr. Webb finally made his way to Salem, where he opened a medical practice. He also began courting Cassandra. The two were married on February 5, 1827. Ford's wife, Susan, died shortly thereafter. Dr. Webb eventually located his brother in St. Louis. John had been released by the river pirates and made his way downriver to Fort Massac. In despair at ever seeing his brother again, John Webb had followed their original intention, made his way to St. Louis and opened a business. Dr. Webb always maintained that Ford's daughter never knew the evil deeds done by her father.

About 1823, Ford established his Ferry Ohio about two and a half miles above Cave-in-Rock. It had been the site of a ferry known as Frazer's Ferry. He bought the land, the ferryboat and the horses that propelled it. Ford's Ferry Ohio used four horses walking about a capstan that, through a series of gears and pulleys, propelled a paddlewheel for propulsion. The next nearest ferry was Flynn's Ferry upriver at the bend of the river at what would become Weston, Kentucky. The closest downstream was at McFarlan's Ferry (now Elizabethtown, Illinois).

About two hundred feet from the river on the Kentucky side was a ferry house consisting of two log cabin structures with a covered dogtrot between the cabins. Vincent Simpson ran the ferry and lived at the ferry house with his wife. Across the river, the ferry landed at a spot called Cedar Point. Another of Ford's gang, Henry C. Shouse, lived on the Illinois shore. Ford's sons Phillip and William were also involved in running the family's ferry. The sons, along with Isaiah Potts in Illinois, acted as Ford's chief lieutenants in the gang. The Cave was the gang's gathering place for making plans and distributing plundered goods and money. The Cave was conveniently located between the ferry operation and Ford's home across from Hurricane Island.

Ford used his influence in the community to improve an eight-mile section of road in Kentucky leading to his ferry. Signs at crossroads and cards left in roadside taverns leading to the Ohio River advertised the advantages of Ford's Ferry and the road that led to it. On the Illinois side of the river, he built a ten- to twelve-mile road at his own expense from the ferry landing to the roadside tavern of Potts' Inn. This road came to be known as Ford's Ferry Road or High Water Road, as it was passable during the rainy season when the river would flood the roads in the river bottoms. The community perceived Ford as an honest man looking out for the welfare of settlers passing through. If word got out that there were

The remains of James Ford's High Water Road or, more commonly, Ford's Ferry Road. The road was maintained from the ferry landing on the Ohio River to Potts' Inn ten to twelve miles away. *Author's collection.*

highwaymen on the trail, Ford soon spread the word that he had run the would-be robbers out of the country.

The general plan was to have the Ford's Ferry gang "resting" at the foot of Pickering Hill on the road leading to the ferry. They would tell travelers the story that they were on their way to Illinois too and offer to accompany the travelers so that they could all travel safely. While making their way to the ferry landing, the gang would ascertain whether the travelers had provisions, livestock or money worth stealing. If they were poor, they would be allowed to travel unmolested. If they did possess something the gang wanted, then Ford's gang had several opportunities to rob them.

The road from Pickering Hill to the ferry landing had several curves and was well secluded—a perfect place to rob someone without being seen. A small cave with a rooftop opening was nearby and served as a convenient place to dispose of bodies. The ferry house at Ford's Ferry doubled as an inn for travelers who arrived after dark. They could get a meal and a place to sleep out of the elements. Often, they never woke up.

If the travelers made it to Ferry Ohio and over to Illinois, the gang had one last chance to rob them. At the end of Ford's Ferry Road at the base of Potts' Hill sat a roadside inn for travelers. The inn was about a day's ride

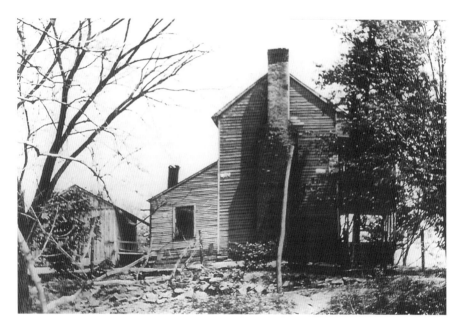

Potts' Inn as seen from Ford's Ferry Road. The road ran along the west side of the inn between the inn and the infamous spring. *Author's collection.*

from the ferry landing in Illinois and made a convenient place to stop for the night. Isaiah Potts (also known as Billy Potts Sr.) owned the inn that was the last stop on the trail, and he encouraged visitors to stop and rest overnight and to have a drink from the cool spring flowing nearby. Potts was also a member of the Ford's Ferry gang.

Although travelers used the main Ford's Ferry Road to reach Potts' Inn, another trail nearby called the Nigh Cut was only wide enough for a single rider on horseback to pass. If a traveler was headed north on Ford's Ferry Road, a gang member could travel the Nigh Cut and reach Potts' Inn two hours ahead of the intended victims and give Potts advance notice. He could then insist on the travelers staying the night and refreshing themselves for the road ahead.

Any women or children were led inside the inn for Mrs. Potts to take care of. Mr. Potts would lead the men to the spring, and while they knelt down to take a drink, he would plunge his knife into their backs. The family would soon be taken care of as well, and all were buried in shallow graves in Potts's nearby field.

One day, Billy Potts Jr. was traveling Ford's Ferry Road when he came upon a man traveling the same direction and asked to join him. As they

talked, Billy discovered the man was well off and probably worth robbing. Billy knew of a convenient spot just ahead on the trail. As they neared the area, Billy pulled a pistol and murdered the man. Two farmers came along when they heard the gunshot and saw Billy standing over the body, pilfering his pockets. At the sight of the farmers, Billy ran. When Ford heard about the incident, he did as he had in the past and instructed Billy to leave the country before lawmen could arrest him. Once again, word got out that Ford had run off a robber.

Billy Jr. lived in other parts of the country for several years. He gained weight and grew a beard. As time passed, he began to long to take a drink at the spring beside the inn as he had as a boy. When he realized he no longer favored his younger self, he decided to visit his parents, sure that his true identity wouldn't be discovered.

As he came over Pickering Hill making his way to the ferry, he was joined by several of his old comrades. Not one of them recognized him as Billy Jr. They accompanied him as far as the ferry, where he revealed his identity. He told the ferrymen he was on his way to the inn to visit his parents to see if he could fool them too. Plans were then made to have a reunion celebration at the inn the next day.

Billy Jr. continued on Ford's Ferry Road, arriving at his parents' inn well after dark. His parents greeted him as they did all strangers to the inn and invited him to have dinner with them. They never suspected this was their prodigal son returned. Before going to bed, Billy told them he was going to take a drink of water from the spring he had heard so much about.

Potts took a torch and led the way to the spring on the opposite side of the road. As his son knelt down to take a drink, Potts plunged his knife up to the hilt in his son's back just under the shoulder blade. As Potts had done many times before, he buried the corpse in a shallow grave, and he and his wife retired for the evening, having scored another haul from an unsuspecting victim.

The next morning, several of the ferrymen arrived, and Potts told them about the easy pick the night before. The gang all asked about Billy Jr., which puzzled the couple, as Billy had been away several years and everyone knew it. The gang members then told of their encounter with Billy the previous day at the ferry. Potts cursed the gang for suggesting Billy had been the one who traveled to the inn the night before.

Mrs. Potts suggested it was a friend whom Billy had told about the ferry and inn. She then remembered that Billy had a birthmark on his back that they could use to identify him. Potts led the way to the fresh grave, and the

The spring at Potts' Inn where the water ran red when unsuspecting settlers took their last drink on earth. *Author's collection.*

body was uncovered. They tore Billy's shirt away, and there near the killing knife wound was the birthmark Billy's mother remembered.

Legends say the grief-stricken parents closed the inn and were never heard of again. This was sometime in the 1820s.

Acting as a justice of the peace, Ford performed the marriage of James Frazer and Elizabeth Armstead in 1817. James's brother Andrew Frazer leased the Lower Lick Salt Works in Gallatin County, Illinois. While staying with Ford in 1828, Frazer became sick and died. It's been suggested he was poisoned. Ford's own wife died about the same time. Ford married the widowed Elizabeth on January 15, 1829. Elizabeth bore him a son, James Jr., in 1830. Through association with the Frazers, Ford became a lessee of the Lower Lick Salt Works. John Crenshaw (see chapter 7) may have been in business with Ford & Co. initially. When Ford died, the lease was reissued and became part of Crenshaw's holdings.

Ford owned many slaves over his lifetime and was probably involved in the slave trade at the salt works near Equality, Illinois. There are several stories of how he punished his slaves. In one account, he punished a slave by squeezing his head in a vise and removing the man's ears and teeth. On August 2, 1832, Ford ran an advertisement in Springfield, Illinois, for

a runaway slave who had been missing since the previous April. In the advertisement, he mentions the slave has no ears as punishment for his involvement in robbing a boat. In another account, a slave was punished by having his hands and feet tied together. Once secured, his feet were then tied to a mule, and a slave was ordered to lead the mule through a field of tree stumps. The man was dragged behind the mule until he was bludgeoned to death. Another story tells of a slave woman who burned the morning biscuits. She was made to stand and ring the dinner bell continually all day until the evening meal.

On January 7, 1829, Ford bought a thirty-four-year-old slave named Hiram from his ferry operator, Vincent Simpson, for $800. Simpson guaranteed the slave was a healthy, hard worker and a good blacksmith. Soon after the sale, Hiram died. In September 1829, Ford sued Simpson, contending Hiram was neither a good blacksmith nor a sound laborer. In fact, Ford claimed he had a hernia and was worth about $250. Ford brought suit for $1,000 in lost time and work.

Simpson tried to counter Ford's claims in court, but Ford brought several witnesses to testify to Hiram's abilities and condition. The case was delayed in court for two years until March 9, 1831, when both parties decided to dismiss the case and pay their own court costs. Simpson continued to run the ferry operations throughout the lawsuit, but Ford had him watched closely. Both men knew too much about the other and could implicate the other in many crimes.

On November 12, 1831, Phillip Ford wrote his last will and testament. The thirty-one-year-old died two days later, possibly of yellow fever. There's also an account that he drowned, but his having so recently drawn his will lends credibility to the theory that he had an illness and knew his time was short. Phillip was a widower and left his estate to his father; his brother William; and a small son named Francis. Five of his seven slaves were to be sold and the proceeds used to support Francis. Dr. Webb and Ford were listed as administers of the estate. A gold watch and chain were to be retained by Dr. Webb until Francis was old enough to receive it.

Less than a year later, William arranged his will on June 1, 1832. The twenty-eight-year-old died that fall on November 3, 1832. Traditionally, he's said to have died from cholera. In his will, he acknowledged two sons that were his. William had never married, and neither mother bore the name Ford. A daughter was also mentioned in the will. If neither son reached adulthood, their portion of the inheritance went to the sister. The balance of the estate went to his uncle, Richard Miles.

Shortly after the death of his sons, Ford's standing in the community began to suffer. He was involved in many lawsuits, and it seemed law and order was continually knocking at his door. Ford realized Simpson knew too much of their operations and could easily implicate Ford in many crimes. Henry Shouse, living near the Illinois ferry landing, was trusted by Ford and instructed to eliminate Simpson. Shouse tried to get Simpson angry enough to fight. He spread the rumor that Simpson was about to claim a reward and testify against the Ford's Ferry gang. Simpson challenged Shouse on the lie, and the two fought. Neither achieved a victory over the other, and both came out badly bruised.

On June 30, 1833, about a week after the incident with Shouse, Simpson rowed down to Cave-in-Rock and became drunk. When he returned that evening, he landed at Cedar Point and began walking up the hill to Shouse's house. Before he could make it to the door, Simpson was shot in the back by a rifle from an upper window of the house. Simpson was carried back across the river to the ferry house and died the next day.

When authorities arrived at Cedar Point, they found that Henry Shouse wasn't home. Shouse's two close associates, James Mulligan and William H.J. Stevenson, were probably accomplices in Simpson's murder. All three men had fled the area. Dispatches were sent throughout the region for information leading to the apprehension and arrest of the three men.

On July 5, 1833, a group of twelve men gathered at the ferry house to determine what should be done about Simpson's murder. It was decided that a group would go to Ford and invite him to participate in the upcoming grand jury. Three men volunteered to ride to Ford's house. They met Ford near the Hurricane Creek Campground. He had heard about the gathering and was on his way to the ferry house to join them. Together, they rode back to the ferry landing, arriving after dark.

Mrs. Simpson had prepared a meal for the group. Due to the number of people, they had to eat in two shifts. Six men went to dinner while the others lounged in the dogtrot waiting their turn. Ford was with the group waiting. Gradually, each of the others drifted off until Ford was left alone leaning back in a chair against the log wall.

One of the men brought Ford a letter to read and held a candle so Ford could see. A shot rang out from the dark. Someone standing among the rose bushes in the front yard shot Ford through the heart. The bullet embedded in the log behind him, and he fell to the floor. An alternate version of Ford's death has it that the chinking was removed from between two logs and Simpson's young son was allowed to pull the trigger that killed Ford. The

body was delivered to his widow by an ox cart the same night. This was one of the last acts of a Regulator company in the area. The men gathered at the Simpsons' had decided to rid the country of the Cave-in-Rock robbers and the Ford's Ferry gang for good.

Ford's funeral was held two days later. His widow, Elizabeth; his daughter, Cassandra; Dr. Webb; the young children; two neighbors; and a few slaves were the only attendees. During the burial service, a summer thunderstorm started to blow. While the slaves were lowering Ford's casket, a crack of thunder and lightning startled the men. The coffin was dropped head first into the grave and became tightly wedged. It began to rain, and the slaves were unable to right the coffin, so they covered it in that position. It was said the slaves remarked that Ford went "head first to hell."

Shouse, Mulligan and Stevenson were apprehended on the Arkansas border. They were apparently trying to escape to Texas. During their transfer back to Illinois, they tried to escape, so each had their ankles tied together under the horse they were riding. The murderer and his accomplices were brought back to Equality, Illinois, for trial. Cave-in-Rock was part of Gallatin County at that time, and Equality was the county seat from 1826 to 1851.

In September 1833, Shouse was indicted by a grand jury for the murder of Vincent Simpson. Mulligan and Stevenson were indicted as accessories to the murder. A total of fifteen people testified for the prosecution. No one testified on behalf of the three men. For the trial, a change of venue was granted to Pope County, Illinois. Trial was set for November 21, 1833.

Shouse's attorney, Judge Wyley P. Fowler, tried repeatedly to postpone or delay the trial. In the months after the indictment, Mulligan died in prison. The other accomplice, Stevenson, escaped and fled the area. Shouse pleaded not guilty. The trial began on May 21, 1834, in Golconda, Illinois, and lasted two days. Apparently, Shouse never implicated Ford in any criminal activity.

After all testimony had been heard, the jury was sent to deliberate. A man named William Sharp appeared before the court and demanded his evidence be heard. Sharp told the court that a week before Simpson's death, he heard Simpson threaten to take a pistol to Shouse's house and settle their disagreement. Fowler then called for a retrial no matter what verdict the jury came back with. The motion for retrial was overruled.

Shouse was found guilty and sentenced to hang on June 9, 1834. While awaiting his execution, Shouse confessed several names of the gang's associates to Judge Fowler. Fowler received anonymous letters threatening his life if the list was ever released. When asked later, he vowed he had destroyed the list of names and no good would have come from releasing it.

Just north of Golconda on the creek bank was a large flat area surrounded by a hillside forming a natural amphitheater. A set of gallows was erected with two heavy timbers and a cross piece. Shouse was taken to the place of execution, sitting on his coffin hauled in an ox cart. Shouse's hands were bound behind his back, and he was blindfolded. Shouse was made to stand on the coffin under the gallows, and the noose was tightened around his neck. At a signal, the cart was moved forward, and Shouse fell. This was the end of the Ford's Ferry gang.

Shortly after Ford's death, his widow, Elizabeth, died as well. James Ford Jr. then went to live with his stepsister Cassandra and Dr. Webb. In October 1844, Dr. Webb, his daughter and James Jr. died when the steamboat they were traveling on, the *Lucy Walker*, exploded. After Ford's death, the Cave was never again the center point of criminal activity.

Author's Note

According to Snively in *Satan's Ferryman*, Charles Webb actually came from Kentucky and studied medicine at the Transylvania Medical College in Lexington, Kentucky. This was in 1822 or 1823. Webb started his practice in Princeton, Kentucky, not Salem, and married Cassandra in 1827. Dr. Webb and Cassandra may have met in the course of his medical practice, and the river pirate robbery and subsequent ankle injury may be just legend.

The land Potts' Inn sat on is shown to have been bought by Isaiah L. Potts of Union County, Kentucky, on September 14, 1814. Potts had two children: Amos F., born 1805 in Loudoun County, Virginia; and Isaiah Jr., born 1808 in Warren County, Kentucky. There's no mention of a senior or junior Billy Potts in the historical record. Isaiah Jr. couldn't have been the "Billy" of folklore tales because he lived to be seventy-seven years old. Neither does history record what happened to Potts's first wife, Elizabeth.

In October 1811, Isaiah Potts married Mary "Polly" Blue in Union County, Kentucky. If the two had a child named Billy, he would have been a teenager when the events of the killing and being seen by the two farmers occurred. Regardless, there's no record Potts fathered any children with his second wife. In April 1832, an inquest was held when David Potts died at the inn. This is either the father or brother of Isaiah Potts. David Potts had been living at the inn for two years when he died.

Potts held many positions in Illinois. He was at various times a ferry operator on the Saline River about a mile north of the inn, a bondsman for

elected officials, a road supervisor for the court and a justice of the peace. In March 1820, Potts was appointed to review and adjust the accounts of the overseers of the poor in Rock and Cave Township. It's surprising that a "known criminal" in Ford's gang would have been granted this much authority over community affairs. However, Potts was an associate of James Ford and appears on his ferry license on December 1, 1823.

In 1834, Polly sued for divorce. The divorce was settled out of court by her brother, Solomon Blue. Potts was forced to pay a settlement of $1,000. We may speculate that the large divorce settlement could have been hush money over what he had done to their son. Either due to the settlement or other factors, Potts's fortunes began to change. The inn and property were sold to John Siddall at public auction on January 10, 1835, to settle debts.

Solomon Blue bought the inn on August 28, 1837, and sold it to Andrew and Thomas Tawzer. Throughout the years Sidall and Blue owned the property, Potts continued to live on the premises. Isaiah Potts apparently lived at the inn from 1814 to 1843. What happened to him after 1843 is unknown, but Isaiah isn't listed on the 1850 census.

An excerpt from the diary of J.J. Williams has been made available by historian Jon Musgrave on hardin.illinoisgenweb.org. Williams kept this journal while traveling through southern Illinois in 1854:

> *Oct. 25th: Food for horses being scarce, we provided ourselves with corn directly after we started. The road was still hilly this morning as it had been for two days. Soon after leaving camp on coming to the top of a hill a beautiful sight burst upon our vision: the hills stretched afar away in the distance, some trees were clothed in the variegated hues of Autumn; some of them were yellow, some red and some still wore the fresh green of spring. The scene as it lay all bathed in the morning light and the hill after hill stretching away below and around us, was truly enchanting and beautiful. We came to the foot of Patz' [sic] hill about ten o'clock; there is a house at the foot of the hill where legend says many a man has stopped for the night and never been heard of more. It looks like a place for deeds dark and dreadful. The hills and rocks around have a wild and fearful look about and seem to be a fit place for the ghosts of the murdered dead, to howl in. It may be fancy, but the house itself has a forbidding appearance, every shutter was closed but those that were broken off and looked like they might have been shut for half a score of years. Came to some tolerable level ground and camped within four miles of Equality, near a salt spring and several salt wells and the remains of some old salt works; travelled 19 miles.*

JOHN CRENSHAW

John Hart Crenshaw was born on November 19, 1797, in North Carolina. He was supposedly the grandson of John Hart, a signer of the Declaration of Independence. His family moved to New Madrid, Missouri, in 1808 and then to Gallatin County, Illinois, moving near the Half Moon Salt Lick. He married Francine Sina Taylor on October 1, 1817, in Gallatin County. Sina was born in 1799 in Virginia and was a cousin to President Zachary Taylor. Sina and John were parents to five children.

The Great Salt Springs, also known as the Illinois Salines, in Gallatin County was an important source of salt to prehistoric people. Many of the early Indian trails led to the salt springs. When the French colonized the area, they found Native Americans making salt at the springs. The French continued the practice when they inhabited the area as New France. When Illinois gained statehood in 1818, the Illinois Salines became the property of the State of Illinois and were made available for lease.

Briny water ladled from the wells was boiled down for salt. Trees were cut for miles around the salt works to provide the fuel. When it became too expensive to transport additional fuel to the springs, a wooden pipeline was laid to move the salt manufacturing miles away from the wells where fuel could be obtained.

Since salt making was such a labor-heavy industry and an important financial resource to the new State of Illinois, the initial 1818 constitution allowed for both slavery and indentured servitude to provide labor for the salt works. The 1848 Illinois constitution outlawed slavery but left a form of indentured servitude intact.

Crenshaw leased his slaves where slavery was legal in Kentucky and Missouri to provide labor for his salt works. The leases were supposed to expire after a year. Crenshaw used a loophole to keep the slaves working by carrying them back across the Ohio River to Kentucky and then returning the leased slaves to the salt works for another year. He also kidnapped freed slaves and sold them back into bondage in slave states, operating a reverse Underground Railroad. Crenshaw was known to work with slave traders such as John Harmon and Hardin Kuykendall. For his indentured servants, Crenshaw would refuse to give certificates of freedom to those who had completed their terms of service.

In 1825, Crenshaw was indicted for the first time for kidnapping free blacks. His co-defendants were John Forrester and Preston W. Davis. All were acquitted. The following year, Martha Prather moved to Gallatin County and emancipated her twenty-three slaves on February 7, 1827. Newton E. Wright and others from Tennessee filed a federal lawsuit accusing the then free blacks of being runaways. Crenshaw either testified in support of Wright or was a party in the lawsuit.

In 1828, a black woman named Lucinda and her two children were kidnapped and taken to Barren County, Kentucky. Lucinda named her kidnappers as John Granger and mentioned William and Abraham Granger. One pronunciation of Crenshaw is "Cringer," which sounds very similar to "Granger." John Crenshaw had two brothers named Abraham and William.

To fund state projects, the State of Illinois began selling the salt spring holdings in 1829. Crenshaw took advantage of these sales and began buying the properties. By 1830, he owned three of the nine operations, a steam mill and lumber business, and by 1840, Crenshaw was the sole operator of the salt works.

Crenshaw built a three-story mansion and developed a southern-style plantation called Hickory Hill overlooking the salt-making operations to the south. Hickory Hill was started in 1834 and completed in 1838. A wide passageway on the ground floor was said to allow a carriage to be brought indoors so kidnapped blacks could be brought in unseen.

The third story was reached by a narrow stair and contained up to twelve windowless "cells" where the kidnapped slaves were kept and bred. Each room contained shelves six feet long and two feet wide to sleep on, as well as chains and metal rings. The third floor also had ball and chains, shackles and a whipping post. The only ventilation was provided by two large windows on each end of the central hallway. These windows were also the only source of light.

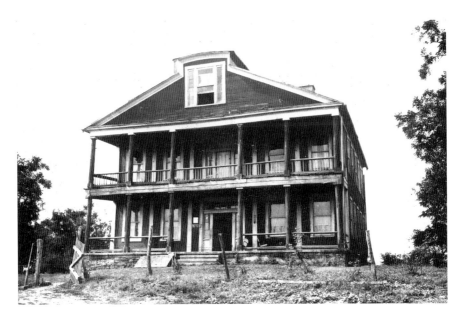

An early postcard featuring the Crenshaw House, advertised as the Old Slave House. *Courtesy of Jeff Robinson.*

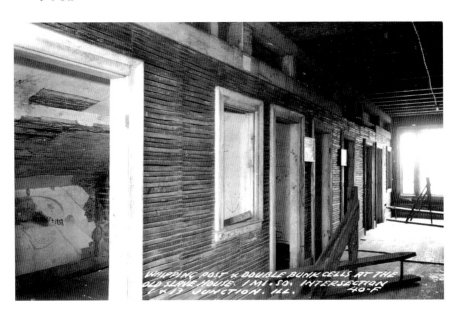

An early postcard featuring the infamous third-story cells of the Crenshaw House. *Courtesy of Jeff Robinson.*

One of the six-by-two-foot sleeping shelves in the cells of the Crenshaw House. *Author's collection.*

Another legend of the third story is of a slave named Uncle Bob. A pregnant slave could be sold for more money than one who was not. Uncle Bob was said to have sired over three hundred children from one of the third-story cells.

Abraham Lincoln traveled to Gallatin County for a week of debates in September 1840. While he was in town, a ball was held at Hickory Hill for attendees of the debates. A portion of the second floor was built with moveable walls in order to provide a ballroom for gatherings such as these. The first-floor bedroom was said to be where Lincoln spent the night, sharing the space with other male attendees.

Charles Adams was born in 1794 and became indentured in 1814 for a period of twenty years. Sometime during that period, Charles's contract was purchased by Illinois governor Ninian Edwards. Charles met Governor Edwards's cook, Maria, and they were married. Maria Adams was born in 1790 and indentured at the age of fifteen for a period of forty-five years. Governor Edwards filed a petition in Randolph County at Kaskaskia that Maria's contract would expire with her husband's. Governor Edwards sold Charles and Maria's contracts to a Colonel Wight. Wight was one of the first lessees of the salt works. He later was a supervisor of lead mines in

The bed that Abraham Lincoln supposedly slept in at the Crenshaw House in 1840. Lincoln was attending a debate in Equality, Illinois. *Author's collection.*

Antiques found in the Crenshaw House. *Author's collection.*

Second-floor parlor of the Crenshaw House. *Author's collection.*

Second-floor parlor of the Crenshaw House. *Author's collection.*

Second-floor bedroom of the Crenshaw House. *Author's collection.*

Galena, Illinois. Charles and Maria pleaded with Governor Edwards to not separate them from their children, so Edwards allowed the children to accompany their parents. For the next four years, Governor Edwards tried to get payment from Wight or to get the children returned to him.

Colonel Wight sold the contracts for Maria Adams; her husband, Charles; a son, Nelson; and a daughter, Ellen, to Crenshaw. In October 1829, Maria gave birth to another daughter named Nancy Jane. Charles's contract expired, and he filed his freedom papers on April 29, 1834. Crenshaw refused to honor Maria's release because Governor Edwards had failed to file an amended indenture.

Ellen Adams's indenture was transferred to Crenshaw's daughter Elizabeth and son-in-law, General Michael K. Lawler. She was probably a wedding present when they were married in 1837. She was released in 1845. Nelson Adams gained his release sometime before 1842.

In early 1842, Crenshaw kidnapped Maria and her seven younger children while Charles and Nelson were away. The Adams farm was about eight to ten miles from Hickory Hill. Crenshaw kept them hidden for several days and then sold them to slave trader Hardin Kuykendall, who carried them away in a wagon in the middle of the night.

Crenshaw and Kuykendall were accused of the crime and tried in Hardin County. They were acquitted on March 28, 1842. It's said everyone knew that they were guilty, but the prosecution couldn't prove they had taken the Adamses across the state line, which was needed for a conviction. Even if Crenshaw had been convicted, the penalty would have been $1,000 with no jail time. At that time, a black man couldn't testify in court against a white man.

Shortly after the acquittal, Nelson and another black man by the name of Fox met Crenshaw on the road when he was returning from the iron furnace in Hardin County. Fox held a rifle on Crenshaw while Nelson demanded to know where his family had been taken.

On April 2, 1842, a group of Regulators came to Equality. They intended to lynch the black men who had attacked Crenshaw and run every free black out of Gallatin County. They warned the citizens in town that they would be back on April 10 to follow through on the threat. The Regulators returned on the promised day and were met in the streets by the townspeople. The citizens mocked the vigilantes by inviting them to "regulate" the black servants in their homes. The Regulators then disbanded without any further provocations.

Nelson, Fox and Charles were arrested. Even though Charles hadn't been present for the confrontation, all three men were convicted of assault with the intention to murder and were sentenced to either four or five years in the state penitentiary in Alton, Illinois.

On December 8, 1846, Shawneetown attorney Henry Eddy, Colonel Wight and Governor Edwards's two sons petitioned then-governor Thomas Ford to pardon the three men so they could help search for Maria and the children. In the request for pardon, Eddy told the governor that Maria and her family were in Texas. There's no evidence they were ever found and returned. The 1850 census shows only Charles Adams still living in Gallatin County. Maria Adams was once the cook to an Illinois governor but apparently died a slave in Texas.

Crenshaw had a leg amputated in 1846. There are three different stories of how it happened. In one account, Crenshaw was beating a young slave girl for scorching the wash. The girl's father heard her cries while he was chopping wood and came to her defense. Another account says that it was from an accident at Crenshaw's sawmill. The third story told was that Crenshaw lost the leg when he got too close to a slave chopping wood.

Crenshaw engaged in kidnapping free blacks from 1830 to about 1848. In 1850, Crenshaw moved his family to nearby Equality, Illinois, and became

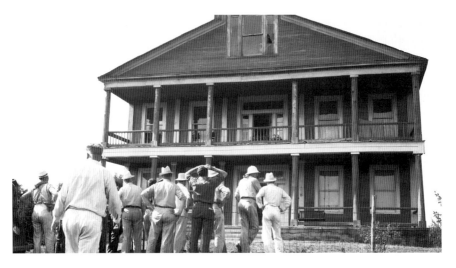

A group of tourists visits the Crenshaw House on the 1938 Trigg Ozark Tour. *Trigg Collection, courtesy of Charles Hammond.*

more involved in the farming of his thousands of acres. He continued in the lumber business, as well as railroads, banking and distilling. Crenshaw died on December 4, 1871. Elizabeth died in 1881.

Hickory Hill was sold in 1864. By 1913, the Sisk family owned the house. The Old Slave House was opened as a tourist attraction from 1930 to 1996. Initial admission was ten cents for adults and five cents for children. The legends of the third story and other aspects of the house were known before the Sisk family opened the house for tours.

Author's Note

The National Park Service named the Crenshaw House a station on the Reverse Underground Railroad due to Crenshaw's practice of kidnapping free blacks. Historians have found at least four cases in which Crenshaw was kidnapping free blacks. He was acquitted in all four cases. The Crenshaw House is now owned by the State of Illinois and is not open to the public.

The leases at the salt works provided a considerable amount of the total revenue for the State of Illinois and led to loopholes in the nonslavery state of Illinois to allow the slave labor. The profit from these salt wells also led the holders of these leases to wield considerable influence in the community.

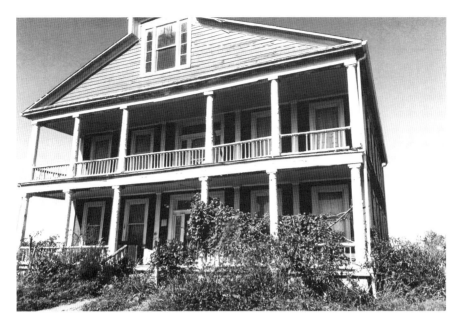

The Crenshaw House, or Old Slave House, as it appears today. *Author's collection.*

Based on the cornerstone of the Crenshaw House, construction may have started in 1838 and been completed in 1842. If this is the case, the mansion would not have been available for the ball that future President Abraham Lincoln attended in 1840.

Southern Illinois University at Carbondale's Center for Archaeological Investigations under Dr. Mark J. Wagner studied the Crenshaw House for the Illinois Historic Preservation Agency. Dr. Wagner's team discovered that the original foundation of the house doesn't support the idea that a carriageway exited into the house. They did discover the remains of a circular drive and the foundation of a back porch. This indicated to researchers that carriages arrived at the back porch, not a secret entrance to the house. They also determined the third-floor rooms or "cells" seem more inclined to be overnight accommodations for visitors or travelers on the nearby rail line. Another point to consider is why someone would conduct the things said to have been done in the third-story "cells" directly over his family's heads, when they could just as easily have been carried out elsewhere on the grounds. Over 150 years of graffiti are on the third-story walls, but none of the early writing seems to indicate anyone was scared of the third floor.

LOGAN BELT

Logan Belt was born on October 10, 1840, in Hardin County, Illinois. He was the son of Hiram Belt, a Baptist minister, who was said to be a quiet and unassuming man who seemed to have little influence on his sons, who grew up to be trouble for the community.

When Logan was twelve, he confronted John and Calvin Palmer as they were passing through Hiram's orchard. Logan told them they were trespassing and to leave. Calvin said he wouldn't be hurried and would go as he pleased. Logan took an axe and hit Calvin on the head. Word got out that Calvin had been killed, and Logan was sent out of the county. Calvin actually hadn't died from the wound and in time recovered. Logan came back a few months later just as mean spirited as ever.

From about the age of sixteen, Logan was taking care of himself. Logan, a brother and another friend rode to Marion, Kentucky, one day. The boys landed at Ford's Ferry (the community that started at James Ford's old ferry landing) and proceeded up the road to Marion. As they traveled, they came upon a boy named Fritts. Logan was itching for a fight and threatened the boy. Logan's traveling companions ran off, thinking Logan would abandon the fight if he thought he was alone.

The boy ran to his nearby house where his mother and sister were. Logan chased him to the house and followed him in. The Fritts family ganged up on Logan and cornered him on a bed. Logan was held down as they took jackknives and repeatedly stabbed him.

Logan's brother and friend realized Logan wasn't with them and went back to the Fritts house to check on him. They rushed in and startled the

Portrait of Logan Belt. *Courtesy of Charles Hammond.*

attackers. They were able to grab Logan and escape, saving his life. Logan's wounds were severe, and it was several months before he recovered from the incident.

Logan spent his teenage years as a hellion in the community. He and his companions would stone neighbors' houses; break into chicken coops in the night, wring the chickens' necks and leave them to die; knock down fences; and leave farmers' gates open. It's said that they would go to one neighbor and steal his horses and stable them at another neighbor's house, often pulling their tails through cracks in the boards and tying them there. Logan would commit a crime in Illinois and then go to Kentucky to escape punishment. Later, he'd commit a crime in Kentucky and return to Illinois to escape justice.

Although he was raised in a Christian home by his minister father, Logan appeared to have no reverence for the house of worship. He would draw characters and leave indecent markings on the walls and disorganize the furniture of the sanctuary to the point where services had to be canceled until things could be set right again.

Logan had no desire for honest labor and wages. He delighted in shocking those he met. It's said that he would beat his head against a tree until the bark was gone just to astonish people. He liked to leave the impression that there was no one in the world like Logan Belt.

On January 13, 1860, Logan married Mary Frailey. She was the daughter of William Frailey, who owned a gristmill on Rock Creek called the Old Water Mill. On July 16, 1863, Logan enlisted in the army in Company D, Forty-Eighth Kentucky Regiment. This was an Illinois company of the Union army during the Civil War. His fellow enlistees chose him as their officer before they left for Kentucky. The unit never saw active combat but was used for guard and skirmish duty in western Kentucky.

Logan's superior officer, Major Hoyt, gave regimental commands, but because Lieutenant Belt wasn't skilled or familiar with military protocol and tactics, he would fail to give proper orders to the company. During the year or so he served, Logan smuggled horses and goods intended for the Union

army's use back to Hardin County. Mary lived with her father during the war. Logan sent his father-in-law and a brother-in-law, Asa Mott, much of the stolen property. Supposedly, a total of eighteen horses or mules were brought to Hardin County during Logan's service.

One of Logan's duties was to notify the citizens to pay their assessments. General Burbridge at Louisville, Kentucky, assessed the Kentucky locals for damages and losses from guerrilla activity against the Union army. It fell on Logan to contact locals who were being assessed and tell them to report to Louisville.

Logan went to one gentleman who was extremely ill and confined to his bed. The man asked if he could be excused or his date to appear postponed until he felt able to make the journey. Logan cursed the man as a Rebel and refused to excuse him. He also wouldn't allow anyone to go in the sick man's place.

In the winter of 1863, the regiment was moved to Russellville, Kentucky. While pressing animals from local farmers for the army, Logan found one gray mare that was superior to the others. This horse was sent back to Hardin County to Asa Mott for safe keeping.

In Bowling Green, Kentucky, a group of government mules was being led across the Barren River. When a few of the mules became stuck in the river mud, the officer in charge gave instructions that anyone who wanted to take the time to recover one of the trapped animals could keep it. One of the teamsters, William Boyd of Hardin County, pulled one of the mules out. The animal nearly died before it came free. Boyd nursed the animal back to health, and after six weeks, it was doing well. Logan took the animal from Boyd and sent it and two others that winter back to Illinois. It's said that when Boyd returned to Hardin County, he told the story many times.

In April 1864, the regiment was moved to Cave City, Kentucky, to guard a bridge over Bacon Creek for the Louisville and Nashville (L&N) Railroad. One of the regiment's horses got into a local man's corn field. The man came to complain and asked Logan to do something about it. Logan cursed the man and told him to take care of it himself.

The horse continued to get into his field, so the man returned with his daughter to ask Logan to help. Logan gave him the same response. The man told Logan he would take care of it. The next time the horse got into his corn field, he'd shoot it. Logan became incensed and knocked the older man down and began kicking and beating him. Several men of the regiment came and pulled Logan away, disgusted at what he had done. Logan was arrested, and a hearing of officers was held. The man's daughter testified

to what occurred. Some of the men in the regiment also testified against Logan. In the end, the case was dismissed by the officers in charge.

While Logan was serving at the Bacon Creek post, several shipments were received in Hardin County. Dry goods and clothing, including soldiers' boots, were sent back. Two large crates were shipped to Cave-in-Rock via Louisville that contained coffee, tea, sugar and blankets from Logan's post at Cave City. Two of the horses that came to Hardin County while Logan was at Cave City were "pressed" from Union army soldiers returning home.

Logan punished a soldier under his command by the name of Richard Edwards by stripping him naked, tying his feet and hands together behind his back and then having buckets of water thrown on him continually. Edwards rolled around in the mud cursing until he was foaming at the mouth. Another time, Logan punished Edwards by having his thumbs tied together and drawn up over his head. He was made to stand with his arms taut over his head for four or five hours.

Logan was given a court-martial at Bowling Green, Kentucky, for scamming soldiers under his command. When a soldier would be short on money, Logan offered to buy parts of his uniform for much less than they were worth. The soldier could later buy the clothing back at Logan's cost. Logan's charges were dismissed without punishment. One day, he was out pressing horses, and a farmer had a horse he wanted. He offered to buy it for $25 even though it was worth $150. The farmer turned him down. Logan told him if he didn't take the deal his entire stable would be pressed for the army's use.

Logan's regiment was mustered out at Bowling Green on December 16, 1864. Prior to the war, Logan had ruined a widow woman's reputation through an illicit relationship. He forced her to trade her forty-acre farm for his, which wasn't worth much. After he returned to Hardin County, he lived on that forty-acre farm a few miles outside Cave-in-Rock. Logan had entrusted $200 to his father-in-law's safekeeping before enlisting. When he went to retrieve the money, Mr. Frailey told him that he could have the money when he settled his wife's bill for room and board. Logan never got the $200 back.

Before the Civil War ended, Logan led a party of men into Kentucky posing as Confederate soldiers. They went to a known Southern sympathizer living in Carrsville, Kentucky. He welcomed them into his home and offered them dinner. Over the meal, he confided in Logan's group that he had guns and supplies he had been able to retain from the Union army. The next day, Logan's men returned dressed as Union soldiers and took the man's three horses, guns and $400 to $500.

Logan was elected constable and became acquainted with the law enough that he was able to practice law in the justice's court. It became a moneymaking scam for Logan because he would secretly keep neighbors fighting with one another so that he could be hired by one of the parties to represent them. He'd charge five to fifty dollars for his services. There were certain justices of the peace living nearby whom Logan knew wouldn't decide a case against him.

An old black man named Fowler Kirk lived three miles outside Cave-in-Rock. One day, Logan took an old bay horse he'd paid $15 for to Kirk's to trade for a mule. Kirk told him he'd paid $150 for the mule from a Pearson in Missouri. Logan took the saddle off the horse, set the animal loose in Kirk's pen and then put the saddle on Kirk's mule. Logan told Kirk to tell everyone that they traded and not to press the issue because he could prove the trade. At that time, a black man couldn't give sworn testimony.

In 1865, Logan had a disagreement with James D. Young. The misunderstanding came to a fight at Potts' Hill. Logan received the worst of the beating. Young was killed on Christmas Eve 1866. It was said that Logan had hired a man named Woods to do the killing.

One day, a man from Kentucky was passing by Logan's house on his way to Raleigh, Illinois, to visit relatives. The man noticed that the gray mare grazing was one Lieutenant Belt had pressed for the army during the war. At Raleigh, the man gathered a group of friends, returned to Logan's after dark and took the horse. Logan found out where the horse had been taken and took his friend Captain Gibson to Raleigh to retrieve the horse.

When they got to Raleigh, they found the horse tied to a rack in town. Logan asked everyone within earshot who rode the animal to town. No one said anything, but one man in the crowd slipped into the nearby grocery store and returned carrying a double-barreled shotgun. He walked up to Logan and Gibson with the gun pointed in their direction. He told them that the horse had been taken from him by Lieutenant Belt when he couldn't do a thing about it, but now they were on equal footing and he intended to take the horse back home to Kentucky. Logan acted as if he might protest, but the man told him to take Gibson and leave while they still could.

The next day, the group left Raleigh for their return to Kentucky. Since they would be traveling by Logan's house again, several of his family from Raleigh accompanied them to the Ohio River. Logan let them pass without incident.

Henry Ledbetter owned the forty acres adjacent to Logan's farm. Logan spent most of his time fulfilling his elected position as constable and used

hired hands to take care of the farm. Samuel H. Dorris was one of Logan's workers. Once Ledbetter's crop was out, Logan instructed his workers to let the oxen and mules into the field to graze. He also told Dorris to cut down two trees on Ledbetter's land.

In 1868, Ledbetter sued Logan for damages in circuit court. When the trial was over, Logan decided Dorris was a liability, as he was the only witness to several of Logan's schemes. Logan confronted Dorris and called him out as a liar. Logan was whipped over the false accusation. Dorris was killed two years later. Dock Clay said afterward that he had been paid fifty dollars by Logan to kill Dorris. Clay disappeared and was never heard of again. Rumor was he was killed and buried near the Shoemaker School stable. Logan had an alibi when Dorris was murdered.

Ledbetter's brother-in-law and sister-in-law were minors who lived in his household. The sister became sick and wanted some cider. Ledbetter sent her brother to Elias Grise's to buy a gallon of cider. He charged sixty cents on Ledbetter's account. A short time later, Grise sold the account to Logan, who sued for the amount on account with the Rock Creek justice of the peace. The judgment went against Ledbetter for the sixty cents plus nine dollars. Ledbetter appealed to the Hardin County Circuit Court in Elizabethtown, Illinois. The circuit court found that the open account wasn't negotiable. Logan lost and was required to pay seventy-five dollars.

Logan used army supplies to barter for services. He promised a pair of boots to a rail maker named Albert Briggs. Logan gave him the boots, and Briggs agreed to make the rails when Logan was ready for them. A few weeks later, Logan sent word that he was ready for the fence. Briggs told him he was in the middle of a project, but as soon as it was finished, he'd take care of his obligation. Logan insisted he come immediately or he would sue him. Briggs offered to pay for the boots outright. Logan refused and demanded Briggs make the rails. Briggs was a large, brawny man. He let Logan know he would rather fight than walk out on his current job. When Logan saw that Briggs was prepared to fight him, he relented and waited his turn.

In 1873, Logan's brother-in-law, Arthur Price, was killed. Logan was suspected of being behind it. Logan had tenant houses on his farm and took in a Tom Jones, his wife and children from Tennessee. The tenant didn't arrive with much, but he did have a good team and wagon. Several in the community tried to help the family make ends meet. Everyone told them they needed to move off of Logan's farm, but the Joneses hesitated to leave.

The husband became sick and died, followed shortly after by the wife. The couple's family in Tennessee was notified and came for the children. Logan

took the team and wagon for his trouble and expenses during the parents' illness. The husband and wife were both buried without any investigation into their deaths.

In the 1870s, the extended families of the Belts and Oldhams were in a feud. Neither side had the advantage, and both were continually finding fault with the other. Lawsuits and fights were common between the families. Attorneys John Q.A. Ledbetter and W.S. Morris fought for a conviction of Logan for twelve years as the state's attorneys of Hardin County.

A traveling peddler came to Cave-in-Rock in 1878 and stopped at one of Logan's tenant farmers. The peddler then stopped at Logan's house, and the two men were seen leaving together. The peddler was found murdered a few days later. Soon after the murder, the tenant farmer was sent to Kentucky and eventually settled in Tennessee, where his family joined him. Several of the peddler's goods were found on the road to the Oldhams' house, bringing suspicion on them. Years later, when Logan's wife was securing money for Logan's defense, a gold watch with an odd chain was used as security on a loan. The watch was very similar to one owned by the peddler.

On December 27, 1875, Thomas Oldham hosted a dance to celebrate the purchase of his new home. Thomas's brother, Elisha "Doc" Oldham, collected twenty-five cents from each guest as they came in the door. Logan and William Lyon arrived at the dance together. Lyon told Doc that Logan was paying for both of them. When Doc went to collect the cover charge from Logan, he told Doc that he wasn't paying for Lyon and he wasn't paying for himself either.

Logan and Doc scuffled across the room. A boy near the fireplace caused Doc to fall, and Logan fell on top of him. Logan grabbed Doc with his left hand as he punched away with his right fist. Frank Dale pulled Logan off just as Doc kicked Logan in the shin. Doc was standing to his feet when Logan pulled a pistol and shot Doc in the chest. Doc died three days later from the gunshot.

Several people witnessed the fight. There was no doubt that Logan had shot Doc at point-blank range. No one could agree who started the actual fight. Just as many said Doc had struck first as said Logan threw the first punch. After Doc Oldham's killing, Logan worked hard to remove witnesses. The Oldhams worked just as hard getting evidence, and bitter feelings intensified between the two families.

Logan Belt was indicted for the murder of Elisha Oldham on April 14, 1876, by State's Attorney W.S. Morris. He was released on a $3,000 bail

bond. Logan developed a plan to delay the trial and eliminate the primary witnesses: Robert Wingate, George W. Covert and Morgan Tucker. Wingate became sick with a fever and died shortly after the indictment. Morgan Tucker's house was watched by men loyal to Logan, but Tucker was able to stay under cover and escape death.

Logan had had dealings with Covert in the past. In fact, Logan had arranged for Covert to marry one of Logan's lady friends, a widow named Sarah Greene. Logan once offered to give Covert a good white horse if he'd kill Thomas and Jesse Oldham. He refused, and Logan was afraid of what Covert might reveal in his testimony.

Covert left Hardin County to stay in Harrisburg. Logan found out and took Jim Belt and Joe Lowry to bring him back. Logan had charges brought against Covert in order to arrest him. When the court reviewed the case in Hardin County, Covert was freed because the charges couldn't be substantiated. Logan didn't care though because Covert was back in Hardin County where he could be dealt with.

For a period of time, it seemed to Covert that Logan was leaving him alone, although Logan's men were secretly watching day and night. Covert felt safe enough to venture out of the house by himself. One day, he was near Logan's house and saw Logan's brother-in-law, William Frailey, beside the road. Covert stopped to talk to him.

Logan saw his enemy across the road and leveled a shotgun at him. Covert realized Logan had him in his sights just in time to duck behind Frailey. Logan fired. Covert's arm was wounded, but Logan's brother-in-law received the brunt of the blast of buckshot. Dr. Dunn lived nearby and dressed Covert's wound for him and got him to safety.

Covert had other charges leveled against him by Logan, requiring his appearance at Hardin County Circuit Court. Several of Covert's friends escorted him to the hearing in Elizabethtown. Meanwhile, Logan went to Constable James Carr and told him he had witnessed Covert breaking into his stable. Carr wrote a warrant for Covert's arrest and gave it to Joe Lowry to serve as soon as Covert was acquitted. Lowry was instructed to take Covert into custody and bring him to Battery Rock that night for trial before the justice of the peace, Squire Henderson.

Before Lowry left, Logan pulled him aside and told him to be sure and bring Covert to Battery Rock by the lower Cave-in-Rock road. Logan told him that the Oldhams would kidnap Covert and hang him that very night. Lowry said that wasn't very likely because Covert and the Oldhams were friends. Logan again told Lowry to use the lower road.

When Lowry arrived in Elizabethtown, State's Attorney Morris looked at the warrant and refused to release Covert. He said that if he released Covert to Lowry, he might as well hang him from one of the courthouse locust trees because the end result would be the same. Morris then told Lowry to return to Logan and tell him that he was welcome to come to Elizabethtown for trial, but Covert would be kept in the county jail until then. Lowry returned to Battery Rock but went several miles out of his way as a precaution.

On April 1, 1879, Luke Hambrink was murdered in his home. Hambrink was a witness at the Oldham killing but wasn't one of the primary witnesses set to testify. Two of his daughters had married into the Oldham family, but there was little love between the Oldhams and Hambrink. Hambrink had been making plans to return to Europe, and Hambrink's murder may have been motivated by property.

The Oldham murder case was kept open for three to four years. In 1879, Logan started a Ku Klux Klan (KKK) organization. The group said it was organized to bring the murderer of Luke Hambrink to justice. Throughout the community, several people received threatening letters. James H. Beavers lost his wheat crop and had his fence burned. Covert was hidden until it was his turn to give testimony at the trial. The intimidation being carried out was so great that the community was on the verge of forming a Regulator company against the Belts and the KKK group. It's said a voice of reason told community members to wait until the verdict at the trial.

In May 1879, Frank Hardin and B.Z. Jenkins lodged a complaint with the state's attorney against Logan Belt for unlawful conspiracy. In the complaint, they stated they were required to attend a KKK gathering. They attended under the pretense that they would be finding the murderer of Luke Hambrink. However, at the meeting, they discovered the true purpose was to whip or kill Covert on the lower road from Cave-in-Rock to Battery Rock.

Warrants were issued for several members of the community associated with the KKK group, including Logan. The sheriff refused to serve the warrants, stating that the only purpose of the complaint was to prejudice the community against Logan. The sheriff actually left the county for a period of time so he wouldn't be called to participate in the case. All but two of those named in the warrant gave themselves up willingly. The trial was held on June 4 and 5, 1879. All were released with $200 fines. Logan later brought perjury charges against Hardin and Jenkins.

In July 1879, the Oldham trial was granted a change in venue due to the KKK interference and was moved to Gallatin County, Illinois. Logan's

defense was based on his need to defend himself. According to Logan's witnesses, Oldham used a set of brass knuckles. Logan's face was cut up from the fight.

During the cross-examination, attorneys Morris and Ledbetter showed that the marks on Logan's face were on the wrong side if they had been inflicted by Oldham. After Oldham's murder, Logan went to the house of one of his friends who lived nearby who then escorted Logan home. The attorneys theorized that Logan then cut gashes in his own face to cover the cold-blooded murder.

During the trial, Covert wore a long-sleeved white shirt. During his testimony, he was asked who had tried to kill him. He pulled back the shirt sleeve, revealing the wound he had received. He used the bare arm to point across the courtroom and named Logan Belt.

A militia was organized in Shawneetown, Illinois, for the trial. Just days before the final verdict was delivered, firearms and ammunition were shipped from Springfield for the militia's use. Sheriff Yost hired fifteen to twenty bailiffs to move Logan to and from the courthouse. On July 22, 1879, the jury was prepared to deliver its verdict. Prior to its being read, Sheriff Yost instructed the courtroom that everyone was to stay seated until the prisoner had been removed to the county jail. One of Logan's friends had a horse saddled and ready at the courthouse for a quick getaway. The courtroom itself was filled with Logan's men who couldn't act due to Sheriff Yost's precautions.

On July 22, the jury found Logan Belt guilty of the murder of Elisha Oldham and sentenced him to fifteen years in the penitentiary at Joliet, Illinois. Logan only served six years of his sentence, but Hardin County enjoyed peace and quiet for the first time in many years. Logan was rumored to have made one escape attempt by clinging to the underside of a wagon, but he was discovered by the guards at the gate.

Logan's wife began converting everything they owned to cash and sent it to Logan, presumably for his attorney. This left his wife and children destitute and dependent on their neighbors. Logan asked his wife to go to the Oldhams and beg their help in getting an early release. They refused to help Logan at all, but they did provide his wife and children with a sack of corn.

Logan tried to get his sentence commuted or pardoned by three different governors. In 1882, three years after sentencing, a petition with 525 names was sent to the governor asking for clemency due to the want and poverty of Logan's family. Ten of the twelve jurors signed a letter asking for Logan's

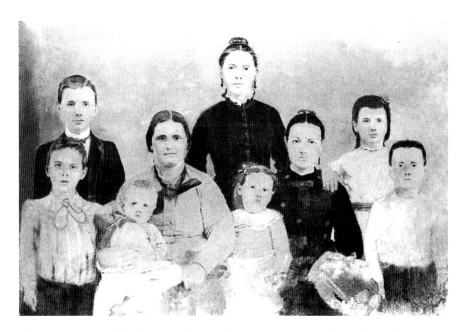

Portrait of Logan Belt's wife, Mary Frailey Belt, and eight of their nine children. *Courtesy of Charles Hammond*.

release. The other two jurors wrote letters of their own asking the same. Most of the people cited the sentence as much harsher than was usual in cases such as Logan's.

Governor Richard J. Oglesby pardoned Logan in 1885, and he returned to Hardin County vowing to be a changed man. He intended to become a Baptist minister like his father. Although the destitute state of his wife and children was often listed as the main reason he needed to be pardoned, Logan's first act upon arriving home was to throw his wife and daughter, Jane, from his house for what he thought were improper relations with the Oldhams.

The same year he was released, Logan joined the United Baptists at Peter's Creek. He was baptized in the winter of 1885. Ice had to be broken on the surface of the creek for the baptism. It appears Logan did everything in his power to avoid breaking the law in any way. He gave liberally to the church and began preaching the gospel of Jesus Christ. Yet people in the community didn't trust him.

After divorcing his first wife, Logan married Mary Amanda Belt from Franklin County, Illinois. Mary was several years younger than Logan. The ceremony was held on October 26, 1886. Three days later, Logan Belt, James

D. Belt, George Ratcliff and Earl Sherwood were arrested and indicted for the murder of Luke Hambrink. A trial was held in April 1887. Logan and the other defendants were all found not guilty and acquitted.

On Monday evening, June 6, 1887, Logan Belt went to the market. It was one of the few times he had traveled away from home by himself since the Hambrink trial. About 150 to 200 yards west of Wesley Chapel, Logan was assassinated by a shot from a rifle while in his buggy.

Marion Belt was Logan's cousin. He had married the widow of Dr. Quillin and raised her son, Bill. One day, Logan went to visit Marion, and the collie dog wouldn't let him come inside the yard. Logan asked Marion's wife to call off the dog so he could come inside, but she refused. She had never cared for Logan and had told Marion she didn't want Logan around. Logan pulled out a pistol and shot the dog, got into his buggy and rode away.

Bill Quillin came home and found his mother upset over her encounter with Logan and the loss of the collie. Bill was furious with Logan. Quillin was an expert marksman and was known to be able to kill a rabbit on the run. William Jenkins was a local gunsmith and would often have Quillin test guns for him to see if they worked. The day Logan was killed, Quillin returned a rifle to Jenkins and told him to say nothing about it. Quillin left Hardin County the day after Logan was killed and never returned. His stepbrother traced him to Oregon years later, but Quillin had already died. Bill Quillin is the man the Belt family always believed killed Logan.

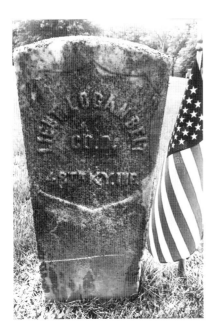

Grave site of Logan Belt. *Author's collection.*

Aaron Lambert was supposedly Quillin's accomplice and lived most of his life in fear that the Belts would track him down for revenge. He fled Hardin County after Logan's murder, leaving behind a wife and children. Lambert returned to Hardin County late in life when his family assured him that he wasn't anyone's target. Lambert insisted Bill Quillin was the one who shot Logan Belt.

Author's Note

Most of the information in this story came from the book *The Life of Logan Belt* by Shadrach Jackson. The book was written shortly after Logan's death. The book's author was a newspaper publisher from Cave-in-Rock who published a series of articles in his paper against Logan Belt. The book and articles are extremely biased.

A Belt family descendant, John M. Belt, wrote *Who Killed Logan Belt?* to give a more balanced coverage of Logan's life. According to John Belt, Logan's military record is without blemish. He also goes into detail about the community's effort to gain Logan an early release, which goes contrary to the public sentiment toward Logan reported by Jackson.

The Cave in the Rock

Christopher Dufrost de La Jemeraye (1708–1736) was a French cartographer who produced the first European map of New France in 1733. About 1739, Gaspard-Joseph Chaussegros de Lery revised the map and called the Cave *caverne dans Le Roc* (Cave in the Rock).

Pierre-Francois-Xavier de Charlevoix (1682–1761) described the Cave in his *History and General Description of New France* in 1744.

The first account of the Cave with details is credited to Zadok Cramer (1773–1813) in the *Ohio and Mississippi Navigator*, published first in 1803 and subsequently revised several times. This was a popular guidebook for those traveling the Ohio and Mississippi Rivers, especially novice flatboat operators taking their first cargos. The quote that began the introduction to this book was a description by Thaddeus Harris in 1803.

Fortesque Cuming (1762–1828) described the Cave this way in *Cuming's Tour to the Western Country (1807–1809)*:

> We thought we saw the Rocking cave, when we observed a cavern forty-five feet deep, three wide, and nine high....
>
> Rowing along shore with the skiff we were soon undeceived as to that's being the Rocking cave, as a third of a mile lower down, one of the finest grottos or caverns I have seen, opened suddenly to view, resembling the choir of a large church as we looked directly into it. We landed immediately under it and entered it. It is natural, but is evidently improved by art in the cutting of an entrance three feet wide through the rock in the very centre,

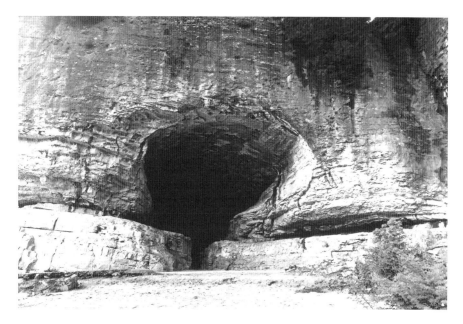

"One of the finest grottos or caverns I have seen, opened suddenly to view, resembling the choir of a large church." Fortesque Cuming (1762–1828). *Author's collection.*

leaving a projection on each hand excavated above to the breadth of the cavern, the projections resembling galleries. The height of the mouth is about twenty-two, and that of the rock about thirty. It is crowned by large cedars, and black and white oaks, some of which impend over, and several beautiful shrubs and flowers, particularly very rich columbines, are thickly scattered all around the entrance. The length (or depth) of the cavern is fifty-five paces, and its breadth eleven or twelve.

Standing on the outside, the appearance of some of the company at the inner end of the cave was truly picturesque, they being diminished on the eye to half their size and removed to three times their real distance.

Over the years, several names have been attached to the Cave: Rock-in-Cave, Rock-and-Cave, Rock Cave Inn, Cave Inn, Cave-Inn-Rock, House of Nature, Rocking Cave and Pirate Cave. Many locals call it simply the Cave-Hole. Lewis Barker founded a town called Rock-and-Cave in 1816. The first post office was established under that name. On October 24, 1849, the postal address was renamed Cave-in-Rock. The town was incorporated as a village in 1901.

There's no consensus on just how the Cave formed. It has been suggested that the "chimney" in the rear of the Cave allowed water to enter and erode the walls. Another possibility is the rock was eroded by yearly inundation by the Ohio River floods. Neither theory is very plausible. Rather than cause the erosion of the Cave, the chimney was actually responsible for filling the back with dirt and debris washed in from the hillside above. The state park built a barrier wall to prevent the erosion. Also, it's very unlikely the yearly flooding would cause the type of erosion seen at the Cave.

The most probable explanation is the Cave was an outlet for an underground stream that no longer flows. The smooth interior walls are unmistakably the work of moving water. The best theory is that an earthquake occurred that blocked and rerouted the underground river flowing out of the Cave in some prehistoric time. Cave-in-Rock is within the New Madrid Fault Zone. An 1811–12 seismic event on this fault is said to have rang church bells as far away as Pennsylvania and caused the Mississippi River to flow backward for a time. Some similar event may have dammed the stream that caused the Cave's formation.

In the early history of Hardin County, there are accounts of the Cave being used for church services.

The retaining wall built around the top of the "chimney" of the Cave to prevent dirt and debris from entering. A grate keeps anyone from falling to the bottom. *Author's collection.*

In the late 1800s, Hardin County was a large producer of potatoes. The year-round cool recesses of the Cave were used to store the potatoes until they could be taken to market. Boats were loaded with potatoes right at the mouth of the Cave.

Sometime before the end of the nineteenth century, an advertisement for St. Jacob's Oil was painted in large six-foot letters over the mouth of the Cave as a sort of billboard to passing boats. St. Jacob's Oil was a liniment for sore muscles that contained chloroform. Throughout the Cave's history, it has attracted people to come ashore and visit this curiosity of nature.

On April 2, 1910, Lee Yeakey and his wife, Mary, bought the six acres of property along the Ohio River where the Cave is located. They paid Mr. and Mrs. F.M. Devers $600 for the property. Yeakey built a house on the bluff above, now known as Flag Pole Hill. While spading ground for a garden, Yeakey found a small stone idol that looked like an old man in a squatting position. It was four inches wide, six inches tall and weighed about two pounds.

Yeakey was a violin maker and held a patent on a particular design. He and his brother-in-law, Captain Richard McConnell Sr., both played as well. Yeakey built a wooden dance floor in back of the cave and put a fence across

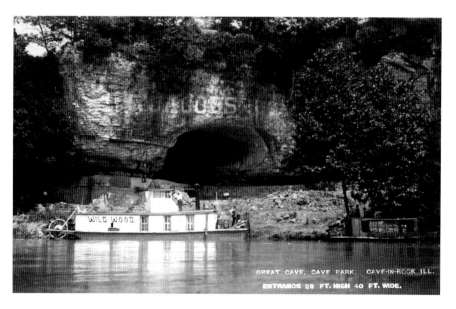

The advertisement for St. Jacob's Oil is visible on the face of the bluff. The Cave made a unique billboard for advertising. *Courtesy of Jeff Robinson.*

Right: A six-inch-tall prehistoric stone idol unearthed on the bluff above the Cave. It's now housed in the collections of the Illinois State Museum. *Author's collection.*

Below: The *Egyptian* packet boat under construction in the Cave. Richard McConnell Sr. is in the boat, and Richard McConnell Jr. (*left*) and Dave Douglas (*right*) are outside clamping planks and boring holes by hand with a brace and bit. *Courtesy of Jeff Robinson.*

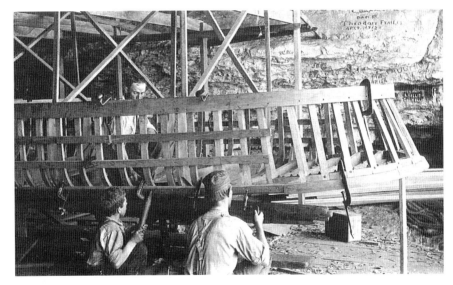

the front with a swinging gate. He held dances on Saturday nights for a five-cent admission. Before the days of movies and television, people were eager for entertainment such as a dance.

Also in 1910, the brothers-in-law, McConnell's son and a friend named Dave Douglas built a wooden-hulled packet boat using the Cave as a dry dock. Because there wasn't any electricity in the cave, every bolt hole was drilled by hand with a brace and bit. That boat was called the *Egyptian*. The steel-hulled packet boat *Katheryne* was also built in the Cave.

The six acres were sold to A.D. and Ella McDonald on October 15, 1919, for $1,500. They continued to live in the Yeakey house and developed gardens and vineyards on the slopes of the bluff. Mr. McDonald died in 1925, but his wife continued to live on the property for several years.

In 1920, county judge A.A. Miles had family coming for a visit and decided to take them to Cave-in-Rock for a picnic lunch in the Cave. The river had been at flood stage and had just recently gone back down. He stopped in Cave-in-Rock and asked some people in town the best way to get to the Cave since the trail along the river was muddy. He was told to take the trail over the hill to avoid the mud.

Judge Miles parked on the hill, and the family enjoyed the view of Kentucky across the river. While they were standing there, Mr. McDonald came along and asked if they had noticed the "Keep Out" signs on their way there. Miles admitted he had, but since the people in town had told him to go over the hill, he hadn't stopped. He went on to tell Mr. McDonald that they had family visiting and promised not to disturb anything. They were just trying to avoid the muddy riverbank.

McDonald was adamant he didn't allow trespassers. Miles apologized, and the group drove back to the riverbank and waded through the mud to have their picnic in the Cave. After burning their scraps at the entrance, they returned to the car. Miles vowed if he ever had the opportunity, he would make the Cave available to anyone.

In January 1929, Judge Miles began serving a term in the Illinois State Senate. He learned the state owned and maintained several state parks, which led him to think about the issue he had at the Cave. Miles was in the processes of authorizing an appropriation for purchasing the Cave property when he found that the state already had an appropriation in place and all that was needed was the governor's consent.

Senator Miles began talks with Cave-in-Rock banker C.C. Kerr about optioning several acres for the park. Kerr was the son-in-law of the McDonalds. Miles enlisted the help of Elizabethtown banker E.F. Wall Jr. and attorney James Watson. Both agreed to work to make the Cave a state park. Before the end of the year, Governor Louis Emerson authorized the initial 64.5 acres. Today, Cave-in-Rock State Park has increased to 204 acres and contains a bluff-top lodge and restaurant, primitive and recreational vehicle camping, several picnic shelters and a paved sidewalk that leads to the Cave.

In 1934, as part of President Franklin D. Roosevelt's New Deal initiative, a Civil Works Administration program removed the dirt and debris from

Workers clearing the dirt from the back of the Cave in 1934 as part of a New Deal project. *Courtesy of Jeff Robinson.*

the back of the Cave to return it to its size during the days of the river pirates. Over the years, the eroding hillsides had filled the back of the Cave through the "chimney" in the cavern's roof. Dynamite was used to loosen the compacted dirt, and then it was loaded into a mining cart and hauled to the entrance by mule. A large level area in front of the Cave was formed. Access to the small "upper cave" was closed off by the state park due to the presence of "bad air." The upper cave was a supposed hiding place for loot and skeletons. In reality, it was just a four-by-ten-foot rock crevice that would have held very little.

In the mid-1950s, Disney Studios came to Cave-in-Rock to film scenes for its Davy Crockett series. The footage was released as a feature film in 1956 as *Davy Crockett and the River Pirates*. The movie features Samuel Mason, the Harpe brothers and a Colonel Plug as villains. At Walt Disney World's Magic Kingdom in Florida, there is a scene called "Wilson's Cave Inn" on the Rivers of America that can be seen on the *Liberty Belle* riverboat attraction. This scene is based on Cave-in-Rock.

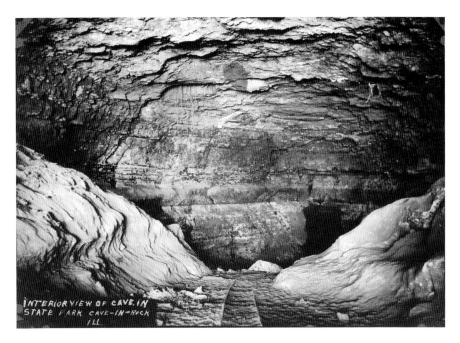

Tracks were laid in the Cave to haul dirt to the front entrance. *Courtesy of Jeff Robinson.*

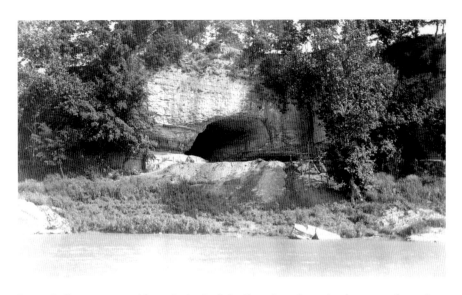

So much dirt was removed from the back of the Cave that a large, level area was formed at the entrance. *Trigg Collection, courtesy of Charles Hammond.*

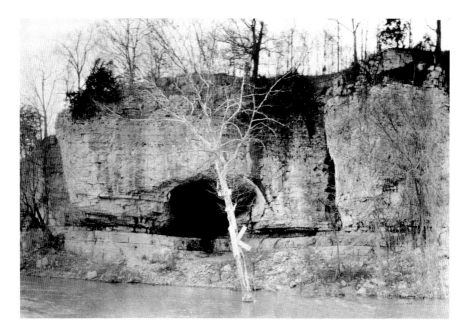

Early promotional photograph of the Cave by the Metcalf Studios. *Trigg Collection, courtesy of Charles Hammond.*

In the early 1960s, MGM filmed *How the West Was Won* on the Ohio River near Cave-in-Rock at Battery Rock. A sequence in the movie shows settlers using a flatboat to travel west on the Ohio River and includes a river island trading post, river pirates and being robbed at the Cave. In 1997, the History Channel filmed a segment on river pirates for its *In Search of History* program using local actors in frontier outlaw roles.

The Cave continues to inspire all who enter its vaulted arch. The home of counterfeiters, river pirates, highwaymen and horse thieves has become a natural wonder to tourists of all ages.

BIBLIOGRAPHY

Books

Allen, John W. *It Happened in Southern Illinois*. Carbondale: Southern Illinois University Press, 1968.

————. *Legends and Lore of Southern Illinois*. Carbondale: Southern Illinois University Press, 1968.

Belt, John Marion. *Who Killed Logan Belt?* Owensboro, KY: Cook & McDowell, 1980.

Bonnell, Clarence. *Illinois Ozarks*. Harrisburg, IL, 1946.

Coates, Robert M. *The Outlaw Years: The History of the Land Pirates of the Natchez Trace*. New York: Literary Guild of America, 1930.

Collins, Lewis. *History of Kentucky: Historical Sketches of Kentucky*. Covington, KY: Collins & Co., 1874.

Finley, Alex C. *The History of Russellville and Logan County, KY.* Russellville, KY: O.C. Rhea, Publisher, 1878.

Hall, James. *Letters from the West*. London: Henry Colburn, 1828.

————. *Sketches of History, Life, and Manners, in the West*. Vol. 2. Philadelphia: Harrison Hall, 1835.

Hardin County Past and Present. Vol. 1. Paducah, KY: Turner Publishing Co., 1987.

History of Union County, Kentucky. Evansville, IN: Courier Co., Printer, Binders and Engravers, 1886.

Jackson, Shadrach L. *The Life of Logan Belt*. Cave-in-Rock, IL, 1888.

Ledbetter, Patricia "Patsy" Pearson. *The Way It Was in Hardin County*. Vol. 1. Cave-in-Rock, IL: Patsy Ledbetter, 2012.

Magee, Judy. *Cavern of Crime*. Paducah, KY: Riverfolk Publishing Co., 1973.

Reynolds, Governor John. *The Pioneer History of Illinois: Containing the Discovery, in 1673, and the History of the Country to the Year 1818, When the State Government Was Organized*. Chicago: Fergus Print Company, 1887.

————. *Reynolds' History of Illinois: My Own Times: Embracing Also the History of My Life*. Chicago: Chicago Historical Society, 1879.

Rothert, Otto A., with a foreword by Robert A. Clark. *The Outlaws of Cave-in-Rock*. Carbondale: Southern Illinois University Press, 1996.

Smith, George W. *A History of Southern Illinois*. Chicago: Lewis Publishing Company, 1912.

Smith, T. Marshall. *Legends of the War of Independence, and of the Earlier Settlements in the West*. Louisville, KY: J.F. Brennan, Publisher, 1855.

Snively, W.D., Jr., and Louanna Furbee. *Satan's Ferryman: A True Tale of the Old Frontier*. New York: Frederick Ungar Publishing Co., Inc., 1968.

Wellman, Paul I. *Spawn of Evil*. New York: Doubleday, 1964.

Magazines

DeNeal, Gary. "Concerning a Curious Silence." *Springhouse* 14, no. 2 (April 1997).

Drucker, Trudy. "An Elfin Coincidence: The Preview of Billy Potts." *Springhouse* 7, no. 5 (October 1990).

Furry, William. "Historic Hulabaloo." *Springhouse* 14, no. 3 (June 1997).

Harpe, Done E. "The Last Rampage of the Terrible Harpes." *Springhouse* 23, no. 2 (n.d.).

Jerome, Brenda Joyce. "Behind the Legends of Ford's Ferry Ohio." *Springhouse* 16, no. 1 (February 1999).

————. "Behind the Legends of Ford's Ferry Ohio." *Springhouse* 16, no. 2 (April 1999).

————. "Behind the Legends of Ford's Ferry Ohio." *Springhouse* 16, no. 5 (October 1999).

Musgrave, Jon. "History Comes Out of Hiding atop Hickory Hill." *Springhouse* 13, no. 6 (December 1996).

Nelson, Ronald. "The Amazing 'Stray Book.'" *Springhouse* 14, no. 3 (June 1997).

————. "In Search of Billy Potts." *Springhouse* 2, no. 3 (May–June 1985).

————. "In Search of Billy Potts, Part II." *Springhouse* 2, no. 4 (July–August 1985).

————. "In Search of Billy Potts, Part III." *Springhouse* 14, no. 3 (June 1997).

————. "John Crenshaw's Infamous Kidnapping Case." *Springhouse* 14, no. 3 (June 1997).

————. "The Raid on Sturdivant's Fort." *Springhouse* 15, no. 2 (April 1998).

————. "Sturdivant's Fort." *Springhouse* 15, no. 2 (April 1998).

————. "To Find a Fort." *Springhouse* 15, no. 2 (April 1998).

————. "Wooden Mills, Wooden Bridges, and Wooden Legs." *Springhouse* 14, no. 2 (April 1997).

O'Neal, Sharon Q. Huffsutler. "The Harpes." *Springhouse* 6, no. 4 (August 1989).

Springhouse 10, no. 3. "Sam Mason." (June 1993).

Springhouse 15, no. 2. "The Honorable Judge Hall." (April 1998).

Springhouse 19, no. 5. "Duff, the Counterfeiter." (Autumn 2002).

Other

Ancestry.com. www.ancestry.com.

Carr, William R. "Isiah L. Potts and Polly Blue of Potts Hill." www.heritech.com/soil/genealogy/potts/uncle_isaiah.htm.

Hardin County. hardin.illinoisgenweb.org.

The 2014 Fall Illinois Ozark Tour. Lecture by Dr. Mark J. Wagner on findings at Crenshaw House by the Center for Archeological Investigations, Southern Illinois University–Carbondale.

Underground Railroad Network to Freedom. "Old Slave House." www.illinoishistory.com/osh-ugrr-app-21-25.pdf.

Wagner, Mark J., and Mary R. McCorvie. "Going to See the Varmit: Piracy in Myth and Reality on the Ohio and Mississippi Rivers, 1785–1830." In *X Marks the Spot: The Archaeology of Piracy*, edited by Russell K. Skowronek and Charles R. Ewen. Gainesville: University Press of Florida, 2006.

————. "The Pirates of Cave-in-Rock in Myth and Legend." Unpublished article, 2006.

WikiTree. www.wikitree.com.

Index